PHILLIMORE'S EDINBURGH

JAN BONDESON

AMBERLEY

First published 2018

Amberley Publishing
The Hill, Stroud
Gloucestershire, GL5 4EP

www.amberley-books.com

Copyright © Jan Bondeson, 2018

The right of Jan Bondeson to be identified as
the Author of this work has been asserted in
accordance with the Copyrights, Designs and
Patents Act 1988.

ISBN 978 1 4456 7831 3 (print)
ISBN 978 1 4456 7832 0 (ebook)

British Library Cataloguing in Publication Data.
A catalogue record for this book is available from
the British Library.

Origination by Amberley Publishing.
Printed in the UK.

Contents

THE LIFE AND TIMES OF REGINALD PHILLIMORE

The Phillimores and the Stiffs are two interlinked old English families with their roots in Gloucestershire and Shropshire. The paterfamilias of the latter-day Stiffs, and grandfather of Reginald Phillimore, was the landed proprietor Thomas Stiff, of Wresden near Uley. This wealthy Gloucestershire magnate would live for many years, to enjoy his favourable prospects in life. Around 1820, when he was thirty years old, he married Elizabeth Harding, and they went on to have five living children, born between 1821 and 1829. William Phillimore Stiff was the eldest child and only son. Emily, the eldest daughter, spent her life in idleness living on private means, but her younger sisters Eleanor, Belinda and Elizabeth all became schoolteachers. Before 1871, Eleanor and Elizabeth clubbed together to buy a school of their own in North Berwick, which they called Wresden House after the old family home; this rather impressive former school is still standing, as the present-day No. 2 York Road. By 1881, Belinda had joined them there, but she succumbed to consumption and died at the school in 1885.

After Elizabeth Stiff Snr had died in 1831, Thomas Stiff remarried the much younger Judith Harding, who may well have been related to his first wife. They had five more daughters, namely Harriet, Isabella, who died in her teens, Cassandra, Rosalind and Adelaide. Harriet also became a schoolteacher, and she taught English in Edinburgh for a while, but died prematurely at her Frederick Street lodgings in 1878, from an abdominal tumour according to her death certificate. The three youngest daughters remained in the parental home until Thomas Stiff expired in March 1869, aged seventy-nine. They then moved to lodgings in London, where they dabbled in art, sculpture and embroidery. Adelaide died prematurely in 1883, but the 1901 census has Rosalind, aged sixty-three and described as an 'Artist', sharing a flat at No. 48 Grosvenor Road, Westminster, with her elder sister Cassandra, who was 'Living on Own Means', and with a lodger. Cassandra died in 1906, as the last of the ten Stiff children; it is notable that none of the nine sisters ever married or had issue.

William Phillimore Stiff, the only son of Thomas Stiff, received a good education, attending the school of the Revd Samuel Barber, of Carne Hall, Bridgnorth. When he decided to become a doctor, he was apprenticed to the local surgeon Mr Joseph Hall. In 1839, he was involved in a riot in Bridgnorth, on occasion of the election of the town councillors, and pleaded guilty at the Crown Court along with ten other rioters. After further studies at University College London and in Paris, he graduated as a Bachelor of Medicine in 1841, qualified at Apothecaries' Hall in April 1842, and became a Member of the Royal College of Surgeons in August the same year.

After some menial medical jobs in London and Sandgate, he was appointed as medical officer to the Nottingham Union Workhouse. This was not a particularly attractive post, but Dr Stiff lacked the ambition and connections to gain preferment in the nepotistic medical world of the time. In 1847, he was involved in an unsavoury case when his patient Charles Hooton died after taking an overdose of morphia, but Dr Stiff was not in any way blamed for this misadventure. In 1850, he read a paper before the Nottingham Board of Guardians suggesting that it would be beneficial to remove certain incurable pauper lunatics from the County Asylum to the lunatic wards of the Union Poor House. In 1851, Dr Stiff married Mary Elizabeth Watts, daughter of the wealthy Mr Benjamin Watts, of Brigden Hall, Bridgnorth. By all accounts, their marriage was a happy one, and it would become blessed with five children: William Phillimore Watts, born in 1853; Reginald Phillimore, born in 1855 at the Stiff family house in Villa Road; Raymund Hawkeswood, born in 1856; Cordelia Mary, born in 1858; and Eleanor Letitia, born in 1866.

In 1854, Dr Stiff testified in Parliament about a case of a mistreated chimney sweep's boy, representing the medical officers of the Nottingham Union in a debate concerning the Chimney Sweeper's Bill. In 1855, he gained preferment and became the superintendent of the Nottingham General Lunatic Asylum at Sneinton. This appointment came with a comfortable house within the asylum grounds, where his five children would spend their formative years. By all accounts, Dr Stiff was a competent, hard-working doctor, who did his best to look after the large, crowded lunatic asylum. He published some brief articles in the *Lancet*, the *British Medical Journal* and the *British and Foreign Medico-Chirurgical Review*, and kept up with the advances of medical science as well as he could. Dr Stiff was a man of some culture, and keen on antiquarian pursuits: he was a long-term member of the Shropshire and Gloucestershire Archaeological Societies, and honorary secretary of Bromley House Library. The 1871

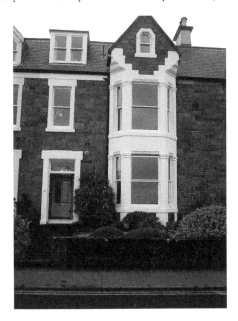

Reginald Phillimore's house 'Rockstowes' at what is today No. 9 Melbourne Road, North Berwick.

census lists the forty-nine-year-old Dr Stiff as living in the Superintendent's House at the Nottingham Pauper Lunatic Asylum, with his now fifty-one-year-old wife Mary Elizabeth and the five children aged between seventeen and five; a certain Joseph Hume Stiff, aged twenty-eight and working as a medical assistant, also belonged to the household. For some reason or other, Dr Stiff intensely disliked his surname, which he wanted to substitute for the better-sounding Phillimore. After being formally adopted by his ninety-two-year-old great-great-aunt Miss Eleanor Phillimore, he assumed the name Phillimore by royal licence in 1873, along with all his issue.

The five Phillimore children, as they will henceforth be called, were taught at home by a governess and a tutor. Reginald and his sister Cordelia Mary both showed promise as artists, and in November 1873, Reginald won a Government Art Prize for the painting of a still life group in watercolour, from nature. The eldest son, William Phillimore Watts Phillimore, went up to Queen's College at Oxford University, where he did well and graduated as a Master of Arts and a Bachelor of Civil Law. In June 1876, Reginald followed him to Oxford, matriculating and joining Queen's College just like his brother. Four years later, he graduated as a Bachelor of Arts with a third-class degree in history. This disappointing degree meant that for him, a further academic career was out of the question. The 1881 census lists the twenty-six-year-old Reginald as a lodger at No. 155 Hatfield Road, Wakefield, and working as an assistant schoolmaster. In between his schoolteaching jobs, he found time to study art in Oxford and Nottingham, but it proved impossible for him to make his living as an artist. His mother had died unexpectedly in 1879, and this was a shock from which Dr Phillimore never quite recovered; he followed her into the grave in December 1881, from liver disease according to his death certificate. His children quarrelled bitterly about the capitalist doctor's testamentary arrangements, which they claimed unduly benefited the eldest son William, who worked as a solicitor and was making himself known as a talented genealogist and family historian. Little money seems to have come Reginald's way, and his father's detailed will merely instructed that he was to be bequeathed 'two paintings of rural life by Morland, six ordinary silver table spoons, six ordinary silver dessert spoons, six ordinary silver tea spoons, and his grandfather Watts' copy of the *Spectator*'; a humble legacy indeed to a second son from quite a wealthy father. Reginald would be stuck with his badly paid assistant schoolmaster's posts, and dreary provincial lodgings, for many years to come.

The 1891 census lists the now thirty-five-year-old Reginald Phillimore and his younger sister Cordelia Mary as lodgers with the widow Mrs Blanche Blogg at No. 8 Bath Road, Chiswick. Mrs Blogg's daughter Frances, who would later marry the author G. K. Chesterton, also lived in the household and befriended the two Phillimores. Reginald described himself as an artist expressing himself as an etcher and sculptor, whereas Cordelia was a painter and watercolourist. In August 1893, the *Norwich Mercury* noted that Reginald had just published an etching of Cromer Church, uniform with his other etched views of Norwich and other cathedral exteriors; author's proof copies were available for a guinea. In November the same year, he published an etching of Lincoln Cathedral, as part of a series depicting the cathedrals of England, which was admired by both the *Lincolnshire Echo* and the *Lincolnshire*

Chronicle. However, this brief burst of newspaper publicity was just a flash in the pan; the cathedral etchings did not sell in quantities, and Reginald had to go back to his travelling life as an assistant schoolmaster. A shy, retiring man, he very much disliked the boisterous pupils and their unseemly shenanigans, and wished to be free of his humdrum day job to concentrate on his art, but since he could not make a living with pen and brush, and since he possessed only a third-rate academic qualification, schoolteaching was the only career open to him. The 1901 census lists Reginald as an assistant schoolmaster living at an Eccles boarding school. Was there any hope?

Yes, there certainly was! We left Reginald's elderly aunts, the Misses Eleanor and Elizabeth Stiff, at their comfortable school, Wresden House in North Berwick. By 1891 the capitalist old ladies had retired from the school and purchased the nice terraced house 'Rockstowes' in Melbourne Road, North Berwick, living there with their elder sister, the annuitant Miss Emily Stiff, and their niece Eleanor Letitia Phillimore. In 1900 and 1901, the Misses Stiff started dying off at an alarming rate. Elizabeth died from heart disease and diarrhoea in April 1900; Eleanor died from apoplexy in October 1901; and the eldest sister Emily succumbed to old age in December the same year. Although the nieces Cordelia and Eleanor Phillimore had both been cultivating the favours of their wealthy North Berwick aunts, and although the elder nephew William Phillimore would formally be the obvious inheritor due to the principle of primogeniture, it turned out that the three old ladies had left both their North Berwick houses, a farm and some land in Bridgnorth, and a healthy sum of money, to Reginald. For him, it would now be possible to start a new and much more agreeable life for himself halfway through middle age.

<div align="center">* * *</div>

As soon as the Scottish legal machinery had ground to a halt after digesting the wills of the three Misses Stiff, the overjoyed Reginald was able to travel to North Berwick to inspect his inheritance. He decided to move into Rockstowes, with its splendid

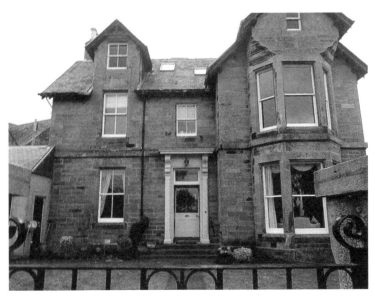

The former school 'Wresden House' at what is today No. 2 York Road, North Berwick.

seaside views towards the Bass Rock, and to let Wresden House to the tenant James S. Lockhart, who ran it as a private hotel. The steady influx of rent from his Bridgnorth properties was another important source of income, as was the interest from the capital invested by the Misses Stiff. The contrast from the impoverished assistant schoolmaster who hated his job to the nearly financially independent North Berwick property owner of great expectations could not have been a greater one. Disgusted at Reginald's good luck, his sister Cordelia Mary went to Portugal, where she started a school. Due to their quarrels about the inheritance money, Reginald had never been close to his elder brother William, who had excelled as a genealogist and published many valuable works on family history. His younger brother Raymund, who had qualified as a doctor, had long since emigrated to Quebec in Canada, where he married and had a family. His youngest sister Eleanor Letitia had married a Bridgnorth man named James Collins Furness in 1900, but he soon left her since he alleged she was impossible to live with, and she died in obscurity at her London lodgings in 1916.

Reginald Phillimore did not want to live in idleness, and anyway there was a need to accumulate money and provide for his old age. At an early stage after he had come to North Berwick, he began to produce picture postcards from his own drawings. All his early cards had local motives, from North Berwick and its immediate surroundings. The earliest stamped and posted Phillimore card in my collection is from April 1904, but noted Phillimore collector Mr Donald E. Beets has cards dated as early as 1902. It may well be that Phillimore produced picture postcards before coming to North Berwick, but this cannot be proven, and no person has a Phillimore card with a Queen Victoria stamp. The start of the picture postcard boom in Britain coincided with Phillimore's move to North Berwick, and the quaint East Lothian surroundings must have inspired him to become a full-time postcard artist. From the bay window of his first-floor study at Rockstowes, he had a good view of the Bass Rock, a steep-sided volcanic rock that is home to many thousand gannets and other sea birds, which inspired several of his early cards.

Reginald Phillimore produced the drawings for his postcards in black and white or sepia, and they were printed in Germany or elsewhere on the Continent by several different printing and publishing companies, making use of the collotype non-screen printing process. He employed a teenaged North Berwick schoolgirl, Mary Pearson, to do the delicate colouring; since she liked some variation, no two hand-coloured cards are the same. Most of Reginald's early unnumbered picture postcards were conventional in that they depicted a standard view, like the Bass Rock or Tantallon Castle, with brief explanatory text. From the very beginning, they enjoyed good sales locally, since people appreciated that they were of superior aesthetic quality. As he grew more experienced, Reginald invented a style of his own for his picture postcards: there was still a main motive, but often several smaller vignettes as well, and brief explanatory text describing the history of the building, close or street depicted. This proved a both novel and felicitous manner to produce a postcard, and Reginald's business flourished as a result. He sold his postcards for a halfpenny each to a network of dealers, initially mainly in the Lothians, but in time all over Britain. Between 1904 and 1914, he was one of Britain's postcard kingpins, admired and collected by many, and easily able to make a living for himself.

Reginald Phillimore was keenly aware of the collecting instinct rampant among the Edwardian postcard fanciers, and he wanted his customers to have a system to classify his cards. Thus, after a few years in North Berwick, he issued a series of numbered cards that would with time extend from 1 until 659. Most, but not all, of his unnumbered cards were reissued with numbers. Already in Edwardian times, he had several hundreds of cards on the market, to be sold by dealers all over Britain. In total, he produced at least 643 distinctive cards, excluding those with only minor variations: of these, 372 have motives from Scotland, 243 from England and fourteen from Wales. In addition, there are four cards with portraits of various worthies, four cards depicting airships or aeroplanes, and six cards from abroad, painted by Cordelia Mary Phillimore. Of the Scottish cards, 193 depicted East Lothian motives, ninety-five were from Edinburgh and eighty-four from the rest of the country. The system of numbering the cards would have been a beneficial one if Reginald had been able to use it in an effective manner, but unfortunately he often got the numbering quite muddled. In addition to the numbered and unnumbered versions of his early cards already discussed, there are numerous instances of the same card having two different numbers, several different cards having the same number, or certain numbers not being used at all. The reason for this bungling is not immediately easy to ascertain, since Reginald enjoyed the Scottish national drink with moderation, and remained fully *compos mentis* throughout his creative period in life. It is likely that he was just muddled and careless, and thus incapable of adhering to the postcard numbering system he had himself created.

Little is known about Reginald's private life during his North Berwick Edwardian fame and fortune. He kept busy producing his cards, some from his own etchings, others from motives in the Lothians that he personally visited, yet others from old prints he procured in Edinburgh. He regularly visited the family property in Bridgnorth, and many of his cards depict motives from this quiet Shropshire backwater. He more than once went on tour looking for inspiration, and visited Gloucester, Malvern, Bath, Bristol, Exeter and the West Country, producing a series of felicitous cards with various local landmarks. He also visited Manchester, toured Northumberland and Yorkshire, and travelled to most parts of the Scottish lowlands. Since he did not approve of Glasgow, only one of his cards (depicting the cathedral) is from the sprawling Scottish metropolis; nor did he like London particularly, and again just one card (St Paul's) is from the English capital. There is nothing to suggest that he ever travelled abroad, and the cards with Italian and Portuguese motives in his series were done by his sister Cordelia Mary, with whom he was obviously still on speaking terms. Reginald remained a shy, introverted man during his North Berwick heyday, with a dislike for social pursuits and a fondness for a solitary life in his comfortable Rockstowes studio. The only woman he is known to have befriended was the aforementioned schoolgirl Mary Pearson, who became his housekeeper once she gained adulthood. Reginald had a liking for golf, and the only extant photographs of him in his prime depicts him together with his friend and golfing partner Dr Richardson, the borough surveyor of North Berwick. Brodie's Bakery, in the High Street, employed Reginald to decorate some frosted shortbread rounds with local scenes to order; these are said to have enjoyed very healthy sales.

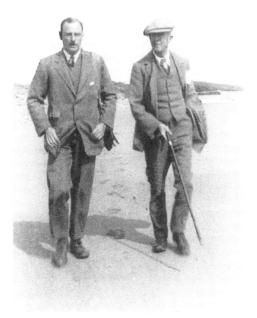

Reginald Phillimore with his friend
Dr Richardson.

Not the least curious fact about Reginald Phillimore's North Berwick career is that he actually became a published author. Perceiving that there was a need for reliable guidebooks to the district, he published *The Bass Rock* (1911), *Tantallon Castle* (1912) and *Guide to North Berwick* (1913). The first two mentioned in particular are sprightly accounts of East Lothian's two foremost attractions, illustrated with felicitous vignettes done by the author himself. Phillimore's guidebooks, published by his own postcard publishing company R. P. Phillimore & Co., were reprinted more than once, but they remain scarce books today. It is not generally known that Reginald also published a novel, under the pseudonym Robert Bridgnorth: the undated *The Wizard of Tantallon: A Tale of Mystery, Love and War*, and again published by R. P. Phillimore & Co. This brief (just seventy-four pages) and unsatisfactory novel was set in the year 1513. The hero is Walter Douglas, a relation of Archibald, 5th Earl of Douglas, who held Tantallon at the time of James IV. A brave and virtuous young gentleman, Walter wishes to marry Alice Ruthven of Dirleton Castle, but her parents prefer another suitor, the wealthy Sir John Grasby. The earl sends Walter to Edinburgh with a letter to James IV, pledging his loyal support against the English. In the capital, Walter meets the astrologer Bordone, a white-bearded, stooped old man, known as 'The Wizard of Tantallon' for his ability to predict the future. He accompanies James IV to the Battle of Flodden, where the king is slain and Walter captured by the English. The villainous traitor Sir John Grasby, who has joined the English army, plans to murder his rival, but Walter subdues him and escapes. In the end, he is reunited with young Alice at Dirleton Castle, and Bordone is one of the guests at their wedding. *The Wizard of Tantallon* may well have been published in 1913 or 1914, but in spite of a few favourable reviews, it hardly sold at all. It is today extremely rare, and only the National Library of Scotland and the University of Aberdeen have copies of it.

The First World War came, with its depressing influence on commerce in general and the postcard industry in particular. Reginald was too old to play any active role in the war effort, but he must have watched the relentless advance of the dreaded Hun, and the initial victories for the spiked-helmeted barbarians on the blood-soaked battlefields of Belgium and the Netherlands, with some trepidation. Although the Zeppelins travelling north for the surprise raid on Edinburgh in 1916 had passed over Gullane, North Berwick would remain a safe place to stay throughout the war years. Reginald sold Wresden House at some time during these years, investing the money in various government funds and trusts. Since a postcard of the historic Whitekirk, 'sacrilegiously burnt by suffragettes 26th Feb 1914' is No. 499 in his series, he must have continued to produce postcards throughout the war years.

When hostilities ended in 1918, Reginald Phillimore was sixty-three years old, but it was not yet time to retire. Since the market for his picture postcards had largely disappeared, he had to conduct an orderly retreat for his postcard company, which once had enjoyed such meteoric success. He sold the occasional painting and etching, and his guidebooks were regularly reprinted, but the influx of money was nothing like it had been in pre-war times. Reginald decided to sell the Bridgnorth farm to ensure his financial security in his old age. A postcard of the airship R34 passing the Law near North Berwick in May 1919 is No. 622 in his series, indicating that he had produced 122 cards since early 1914; from the summer of 1919 until the end of his life, he would make only thirty-seven more cards. The market for his postcards continued

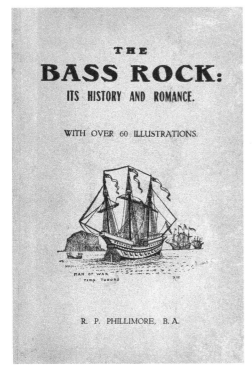
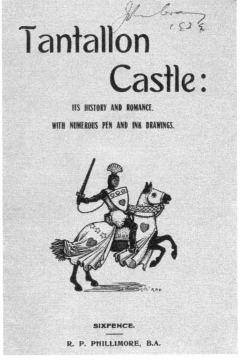

Above left and right: Phillimore's books about the Bass Rock and Tantallon.

to decline: town after town on the English mainland was lost, and shop after shop stopped stocking his cards since they were no longer fashionable, yet he remained well represented in Scotland throughout the 1920, particularly in his Edinburgh and East Lothian strongholds. Messrs Doig, Wilson & Wheatley, of No. 1 Greyfriars Place, stocked his cards and etchings for many years to come.

In the post-war years, Reginald Phillimore was befriended by his nephew Wilfrid Henderson Phillimore, the only son of his elder brother William Phillimore Watts Phillimore, who had inherited his father's fortune and become a landed proprietor in Polmont near Falkirk. This was not far from North Berwick, and Wilfrid regularly visited his uncle; they kept up a brisk correspondence for many years. After serving in the Labour Corps during the First World War, Wilfrid married the Glasgow typist Annie Stewart Cook in 1922, but Reginald does not appear to have disapproved of this *mésalliance*, and the two remained firm friends. Wilfrid was an idle fellow, who liked horses and yachts, and shunned hard graft and honest toil.

Since his remaining brother Raymund Hawkeswood Phillimore had died in Canada in 1911, his sister Cordelia Mary was Reginald's sole remaining sibling. She had taught at a school in Portugal, becoming governess to the royal family according to some accounts. Since she had saved money, and since she never spent sixpence if she could help it, she was a well-to-do old lady when she retired in the early 1930s and moved back to England. Once, she invited her nephew Wilfrid to a tea-room in North Berwick; when he remarked that it was odd that they were having tea out when her brother was living nearby, it turned out that they were not on speaking terms due to some petty squabble. Cordelia Mary moved into a newly restored cottage in Uley, Gloucestershire, but she was driven to despair by the indifferent climate, and very much regretted leaving Portugal. In July 1934, she committed suicide by hanging herself, after first making sure that both Reginald and Wilfrid were cut out of her will; the former, who had been looking forward to a substantial legacy from his wealthy spinster sister, was very much hurt by this unseemly post-mortem spitefulness.

Reginald Phillimore's health, both mental and physical, had always been very good, but in 1936 he suffered a serious stroke, becoming paralysed in the right side of his body and experiencing an impairment of his speech. He seemed to be close to death, but his iron constitution allowed him to rally, although he was crippled for life. On sunny days, the loyal Mary Pearson wheeled him about in an invalid chair, and he liked to sit in the small garden to the rear of his house. He is said to have learnt to write, with difficulty, with his left hand, and even to have attempted, ambidextrously and with a shaking hand, to copy an old watercolour painting of his. Still, this is scant consolation for an artist whose creative power had been broken for good. As the Bass Rock gleamed in the bright North Berwick sunshine, the shadows grew longer in the Rockstowes geriatric gloom. The memories of a man in his old age are the dreams and hopes of a man in his prime, and as Reginald sat lopsidedly in his armchair in the downstairs parlour, he must have pondered his unhappy days as a schoolmaster, the great inheritance triumph in 1901, the heady Edwardian days as one of Britain's postcard kingpins, and the slow but steady post-war decline. His remaining minutes,

Reginald Phillimore in his old age.

hours and days were measured out by the steady ticking of the parlour's longcase clock. On Christmas Eve 1941, the clock stopped. The local doctor signed the death certificate with 'cerebral haemorrhage', an adventurous diagnosis given the patient's previous stroke; two episodes of cerebral thromboembolism seems a much more likely suggestion. He was buried in the family vault at Bridgnorth.

Wilfrid Henderson Phillimore, who had befriended his uncle for many years, of course expected to inherit, but when Reginald's will was read, he only got a few paintings. The bulk of the estate, £1,899 in all, went to the Canadian niece Mrs Enid Chicanot. She directed everything to be sold, except some paintings she had admired when visiting her uncle during his declining years. The disappointed Wilfrid hoped to purchase some of the best paintings and the dilapidated Bridgnorth properties that remained, but his offers were too low. He did, however, have success in securing Reginald's remaining stock of books and postcards. In his old age, Wilfrid moved to the West Country of England, and left the Phillimoriana he had purchased cheaply to disintegrate in some sheds; it was briefly rediscovered in 1984 and used for a Phillimore exhibition at the Dulwich Picture Gallery two years later, but only to disappear once more. Mrs Chicanot, who was still alive in 1962 at the age of sixty-four, had four children who may well have had issue themselves, the only surviving descendants of Thomas Stiff the Gloucestershire magnate. A certain Hugh Phillimore Chicanot (1930–2007) is recorded to have visited Britain, and it is likely that he inherited at least part of the estate of Wilfrid Henderson Phillimore when he died in 1977. As for the faithful Mary Pearson, she was left £400 in Reginald's will, and lived on until March 1969.

* * *

There is a strong argument that Reginald Phillimore's finest work is represented by his Edinburgh postcards, closely followed by his many East Lothian cards. Reginald

obviously had a great fondness for Edinburgh, and he visited the Scottish capital many times; with time, he came to know the city well. He liked to visit the majestic castle, then still unsullied by the frantic hordes of tourists, and to have a quiet stroll around Holyrood, making sketches of some of the state rooms as he went along. He knew the Old Town, with its many quaint and narrow closes off the Royal Mile, like the back of his hand. If Edinburgh is defined from its present-day boundaries, rather than those from Edwardian times, then Reginald Phillimore produced a total of ninety-five Edinburgh cards, the majority of them from the castle, Holyrood and the Royal Mile. Most of these cards came from drawings made by Reginald on the spot, but not all; some of the closes on his Royal Mile cards, like Plainstanes Close off the Lawnmarket, had been lost in Victorian 'improvement' schemes, so here he would have had to rely on old prints of the location in question.

I myself began to collect Reginald Phillimore's picture postcards, those with Edinburgh motives in particular, in 2003 following a visit to the Scottish capital. Fast forward fifteen years and I was in possession of a well-filled album of 'Phillimores', a total of fifty-seven Edinburgh cards prominent among them. Some of his Edinburgh cards are commonly met with and can be purchased for £3 or £5 on a good day, whereas others are so prodigiously rare that they can only be met with at the postcard fair of your dreams. Although having kept a close lookout for fifteen years on various other Internet auction sites, as well as at the large postcard fairs in London and Edinburgh, there are quite a few Edinburgh 'Phillimores' that I have never seen advertised for sale, and others that have gone for in excess of £100.

So why are some of Phillimore's Edinburgh cards so very rare? The choice of a motive must be one factor, with Greyfriars Bobby (No. 471) being commonly met with and Tailor's Hall in the Cowgate (No. 650) very rare; yet Scott's Monument (No. 386), which ought to have been equally popular, is very scarce indeed. The print runs of Phillimore's postcards varied a good deal, and while some were reprinted several times, others were not. Moreover, his late cards, from No. 600 onwards, were published in the years following the First World War, at a time when the interest in buying and collecting picture postcard was no longer strong, and Phillimore's cards had gone out of favour.

Having despaired of ever being able to complete my collection of Reginald Phillimore's Edinburgh cards, even if I lived to become a centenarian, I managed to obtain an introduction to the leading Phillimore collector Mr Donald E. Beets. He kindly agreed to supply scans of all the missing cards, in order to make it a reality that all Reginald Phillimore's Edinburgh cards were brought together for the first, and perhaps also last, time ever. Of superior artistic quality, they provide both a unique view of the Scottish capital as it was back in Edwardian times, and a fitting memorial to a very talented artist whose work has been unappreciated for many years.

EDINBURGH CASTLE

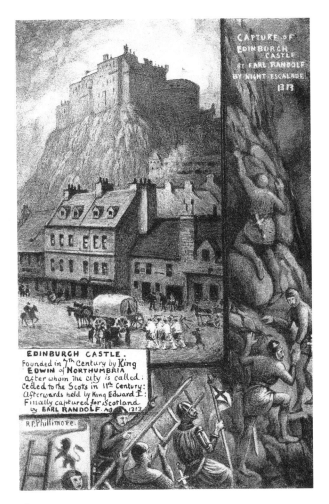

Views of the Castle

Of Reginald Phillimore's sixteen postcards featuring Edinburgh Castle, seven have views of the castle from afar. An early unnumbered card, later reissued as No. 18, shows the castle from the Lawnmarket, with a feature of the daring recapture of the castle by Thomas Randolph, 1st Earl of Moray, in February 1314. Exactly the same view is used in No. 635, but with a feature instead on the escape of Alexander Duke of Albany, who is said to have lowered himself down Castle Rock using a knotted rope. Two variations exist of No. 617, using the same main image of the castle from the Esplanade, but different vignettes of the captures of the castle by Sir William Douglas in 1337, and by Sir Alexander Leslie in 1638. Card No. 428 shows the castle with the National Gallery in the foreground; No. 501 makes use of another standard view with the Ross Fountain in the foreground; and the rare No. 600 shows the castle in the sunset, seen from Johnstone Terrace.

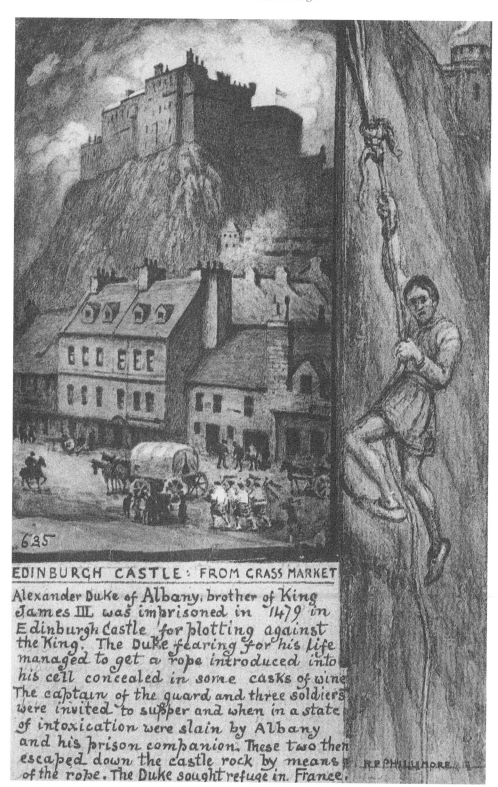

635

EDINBURGH CASTLE: FROM GRASS MARKET

Alexander Duke of Albany, brother of King
James III was imprisoned in 1479 in
Edinburgh Castle for plotting against
the King. The Duke fearing for his life
managed to get a rope introduced into
his cell concealed in some casks of wine
The captain of the guard and three soldiers
were invited to supper and when in a state
of intoxication were slain by Albany
and his prison companion. These two then
escaped down the castle rock by means
of the rope. The Duke sought refuge in France.

R.P.PHILLIMORE.

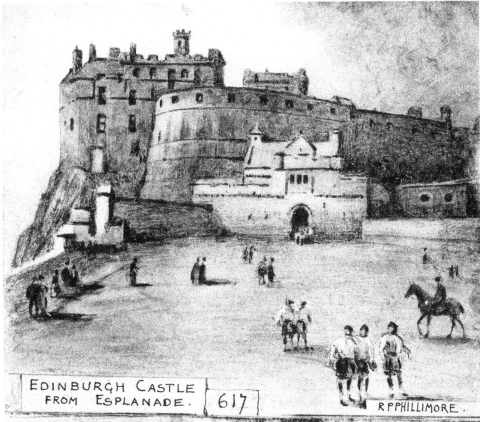

EDINBURGH CASTLE
FROM ESPLANADE. | 617 |

R P PHILLIMORE.

Sir Alexander Leslie's capture of the castle when held
for King Charles I. 23rd March 1638. The first gate being
blown up the Covenanters attacked the second with axes &
sledge-hammers & in 20 minutes they had possession.

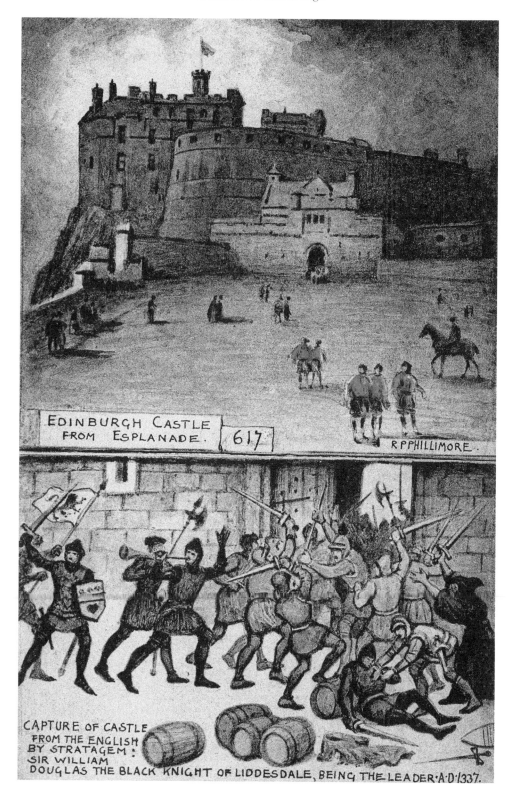

EDINBURGH CASTLE FROM ESPLANADE. 617

R P PHILLIMORE.

CAPTURE OF CASTLE FROM THE ENGLISH BY STRATAGEM: SIR WILLIAM DOUGLAS THE BLACK KNIGHT OF LIDDESDALE, BEING THE LEADER·A·D·1337.

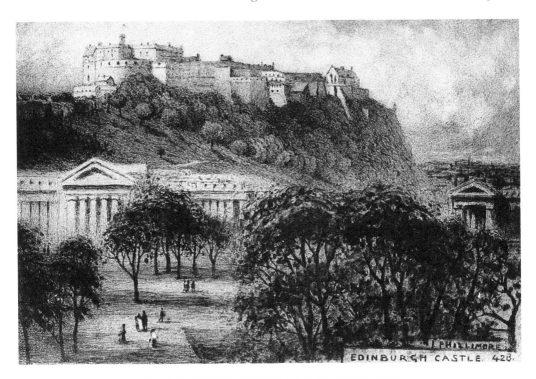

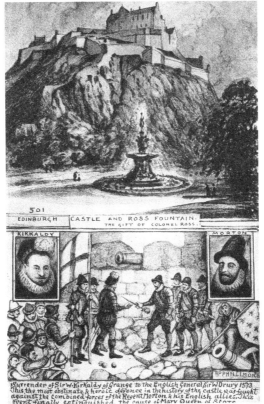

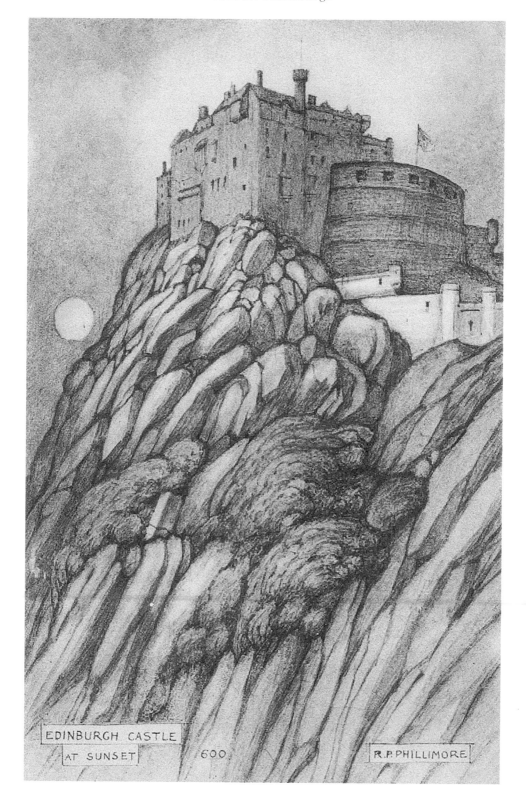

EDINBURGH CASTLE
AT SUNSET 600 R.P.PHILLIMORE

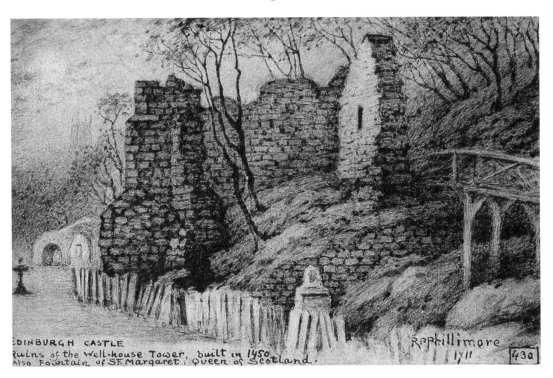

EDINBURGH CASTLE
Ruins of the Well-house Tower, built in 1450.
Also Fountain of St Margaret, Queen of Scotland.

R.P.Phillimore
1911
430

The Well-House Tower

A sight not commonly met with on Edinburgh picture postcards is the ancient Well-House Tower, situated at the foot of Castle Hill in what is today the Princes Street Gardens. The use of this tower, in olden times, was to protect St Margaret's Well, which provided the castle with water. It had been in a very ruinous state for many years when seen by Phillimore around 1910, and it has not improved since. Although there was media publicity in 2005, to the effect that the ancient tower was to be repaired, it presents a most woebegone appearance today. An inscription states that it was restored by the officers of the 93rd Sutherland Highlanders in 1873. The agile and able-bodied can negotiate nettles and piles of dog excrements to have a closer look at the main structure of the tower. It is a strangely desolate place, with the trains clattering by just yards away, and seemingly better suited to raincoated trainspotters than to those with an antiquarian bent, who wish to contemplate the glory that was old Edinburgh.

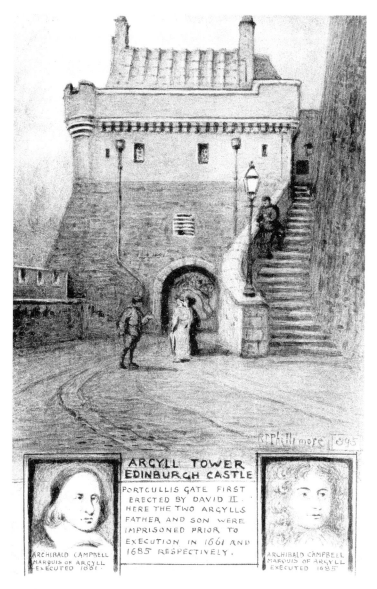

ARGYLL TOWER
EDINBURGH CASTLE

PORTCULLIS GATE FIRST
ERECTED BY DAVID II.
HERE THE TWO ARGYLLS
FATHER AND SON WERE
IMPRISONED PRIOR TO
EXECUTION IN 1661 AND
1685 RESPECTIVELY.

ARCHIBALD CAMPBELL
MARQUIS OF ARGYLL
EXECUTED 1661.

ARCHIBALD CAMPBELL
MARQUIS OF ARGYLL
EXECUTED 1685.

The Argyll Tower

In Victorian times, there was much debate on what to do with the sprawling castle: to restore it with emphasis on originality, or to rebuild it according to various expansive and dotty schemes brought forward by enterprising architects. In the 1880s, a policy of moderation was decided upon, and certain parts of the castle were 'developed' to some extent, whereas the majority of the ancient structure was allowed to remain more or less as it was. In 1886 and 1887, the architect Hippolyte Blanc added another story, in the Scottish Baronial style, to the ancient Portcullis Gate. It was called the Argyll Tower, from Archibald Campbell, 9th Earl of Argyll, who was imprisoned here awaiting his execution in 1685. Today, the Argyll Tower contains a model of the castle, a painting of *The Last Sleep of Argyll* by E. M. Ward showing the stoic earl sleeping soundly on the morning of his execution, and a drawing of the castle rebuilt as a French château, put forward by some iconoclastic architect in Victorian times, which has a certain horrific appeal to those teratologically inclined.

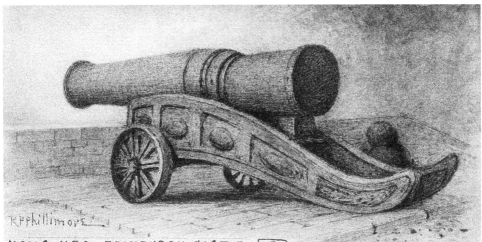

MONS MEG, EDINBURGH CASTLE. [458]
Forged at Mons in 1476. Employed by James II. at the siege of Thrieve Castle when it is said to have carried away the hand of the Fair Maid of Galloway. In 1489 it was used at the siege of Dumbarton and eight years later at the siege of Norham. In 1682 it burst on being fired in honour of the Duke of York. In 1745 it was removed to London but in 1829 it was restored to Scotland through the exertions of Sir Walter Scott.

Mons Meg

One of the most popular sights within Edinburgh Castle is Mons Meg, the ancient siege gun that is on view at the Mortar Battery, next to St Margaret's Chapel. It was built at Mons at the orders of Philip, Duke of Burgundy, in 1449 and given by him to his ally James II of Scotland in 1454. King James made enthusiastic use of his new bombard, and it took part in the siege of Roxburgh Castle in 1460, during which the king lost his life. James IV made use of 'Mons', as the gun was called at the time, at several sieges, including that of Norham Castle in 1497. It would fire a boulder not less than 2 miles and was a useful instrument of war at its time. The problem was that the huge bombard was immensely heavy: even when pulled by a team of 100 men, it could only travel 3 miles in a day. It was retired from military service around 1550 and used as a saluting gun at Edinburgh Castle. In 1558, it was fired to mark the marriage of Mary Queen of Scots, to impressive effect. It was last fired at the birthday salute of the future James VII in 1681; the barrel burst and Mons Meg was dumped near the castle cart shed. In 1754, she was taken to the Tower of London and exhibited there before the curious. A number of patriotic Scots, Sir Walter Scott prominent among them, were keen to have Mons Meg restored to Edinburgh Castle, and in 1829 they had success when George IV allowed her to be taken back home. The rotten wooden carriage collapsed in 1835, causing Mons Meg to fall with a great crash. It was replaced with an iron carriage for some time, but the present-day wooden carriage dates back to 1934.

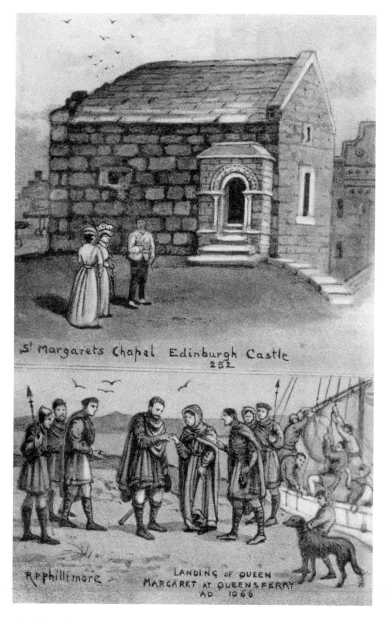

St Margarets Chapel Edinburgh Castle
252

R.P.phillimore

LANDING OF QUEEN
MARGARET AT QUEENSFERRY
AD 1066

St Margaret's Chapel

The oldest building at Edinburgh Castle, and indeed in all of Edinburgh, is St Margaret's Chapel, constructed around the year 1130 by David I as a private chapel for the royal family. Queen Margaret, the consort of Malcolm III, was an English princess of the House of Wessex. A very pious Roman Catholic, she made sure that a ferry service was established across the Firth of Forth for the use of pilgrims, giving the towns of North and South Queensferry their names. Queen Margaret died at the castle in 1093, still mourning Malcolm III and her eldest son Edward, who had both fallen at the Battle of Alnwick, and was buried at Dunfermline Abbey. She was canonised by Pope Innocent IV in 1250. Her sons Edgar, Alexander and David in turn became Kings of Scotland, and it was the latter of them who ordered the chapel to be erected in her honour.

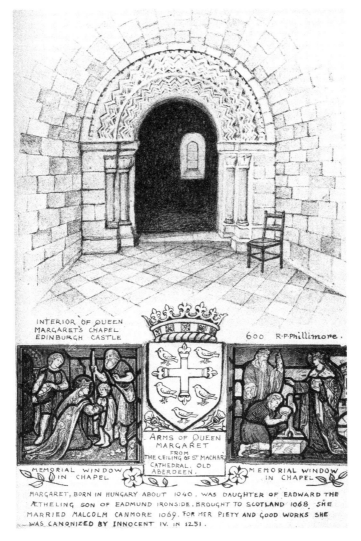

INTERIOR OF QUEEN
MARGARET'S CHAPEL
EDINBURGH CASTLE

600 R·P·Phillimore.

ARMS OF QUEEN
MARGARET
FROM
THE CEILING OF ST MACHAR
CATHEDRAL, OLD
ABERDEEN.

MEMORIAL WINDOW
IN CHAPEL

MEMORIAL WINDOW
IN CHAPEL

MARGARET, BORN IN HUNGARY ABOUT 1040, WAS DAUGHTER OF EADWARD THE
ÆTHELING SON OF EADMUND IRONSIDE. BROUGHT TO SCOTLAND 1068. SHE
MARRIED MALCOLM CANMORE 1069. FOR HER PIETY AND GOOD WORKS SHE
WAS CANONIZED BY INNOCENT IV. IN 1251.

There has been speculation that St Margaret's Chapel was part of a larger complex of royal buildings, demolished when Robert the Bruce sacked the castle in 1314, but this cannot be proven with certainty. In spite of its plain exterior, the chapel is handsomely decorated within, with an original chevroned arch dividing the apsidal chancel, housing the altar, from the nave where the royal family once sat down to worship. The chapel fell into evil times in the sixteenth century, when it was converted into a gunpowder store, but the antiquary Sir Daniel Wilson discovered its original use and supervised its restoration. When Phillimore came to sketch the castle in Edwardian times, St Margaret's Chapel was one of its foremost attractions, and it is commonly seen on the postcards of his time. One of Phillimore's postcards features the outside of the chapel, with only three people standing where hordes of tourists are thronging today, with the bottom panel depicting Queen Margaret landing at Queensferry in 1066. The other card features the interior of the chapel, with two 'memorial windows' being reproduced; these are no longer present today, since a set of stained-class windows by the artist Douglas Strachan, depicting St Margaret, St Columba, St Andrew, St Ninian and William Wallace, were added in 1922. In spite of its diminutive size, the chapel is still occasionally used for christenings and weddings among the higherclasses of people.

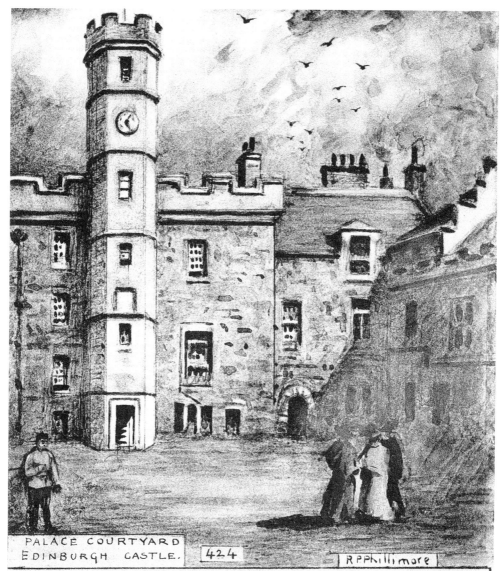

PALACE COURTYARD
EDINBURGH CASTLE.

424

R P Phillimore

MARY OF GUISE

Palace Courtyard
was for centuries
the stronghold of
the Kings & Queens
of Scotland.
The door in the octa
gonal tower leads
to the crown room.
The door on the
right leads to the
room in which
Mary of Guise died
in 1560. Here also
is the birth room
of James VI.

MARY QUEEN OF SCOTS.

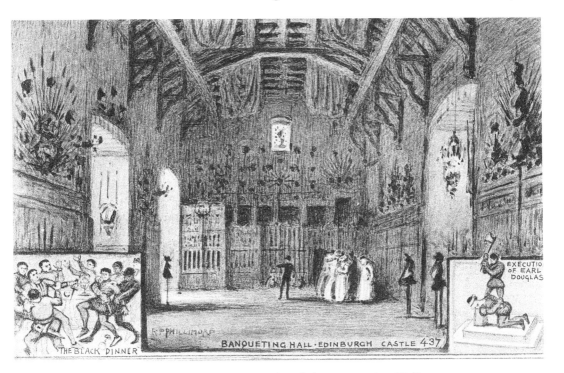

THE BLACK DINNER

R·P·PHILLIMORE

BANQUETING HALL·EDINBURGH CASTLE 437

EXECUTIO OF EARL DOUGLAS

Above and opposite: The Palace Courtyard and the Banqueting Hall
The castle's main courtyard was created in the late fifteenth century, then being contained by four buildings: the Royal Palace, the Banqueting Hall, the Royal Gunhouse and St Mary's Church. The gunhouse has since been replaced by the Queen Anne Building, and the church by the sprawling Scottish National War Monument, but the situation of the courtyard remains more or less unchanged. Phillimore's card shows the octagonal clock tower, with the door leading to the chamber where the Honours of Scotland are today exhibited before the gawping crowds. The door to the right still leads to the main royal apartments.

The Banqueting Hall was completed in 1511 under the reign of James IV. He perished at the Battle of Flodden two years later, and his heirs preferred the luxuries of Holyrood to the heights of Castle Rock, meaning that the Banqueting Hall saw little use, although Mary Queen of Scots is recorded to have held a banquet there in 1561, after her return from France. With his usual Scotophobia and disdain for ancient monuments, Oliver Cromwell had the Banqueting Hall converted into barracks to house his marauding troops, and it would remain in military hands for more than two centuries.

When the aforementioned architect Hippolyte Blanc was employed to restore the Banqueting Hall in 1887, he was cheered to find that the original medieval roof was still in good order, as were the decorated stone corbels with curious Renaissance symbols. Otherwise, Blanc had a carte blanche with regard to the restoration: he added a grand fireplace with statues inspired by medieval poetry, a Gothic timber entrance screen and plenty of heraldic stained glass. The result must still be said to be a felicitous one, and the Banqueting Hall remains an impressive sight today, even when filled almost to capacity with frantic tourists, making liberal use of their mobile telephones to document its presumably ancient features and archaic armaments displays during their hectic 'Do Scotland in Three Days' whistle-stop tour of the major Caledonian landmarks.

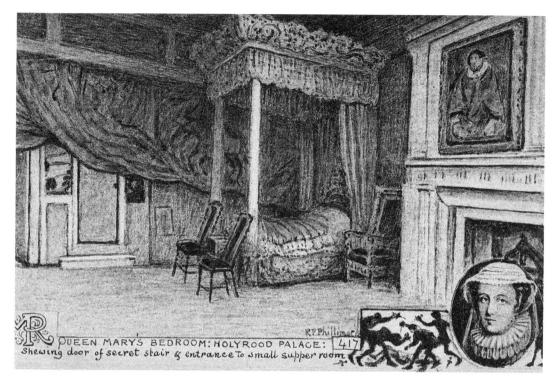

QUEEN MARY'S BEDROOM: HOLYROOD PALACE: 417
Shewing door of secret stair & entrance to small supper room

Queen Mary's Bedroom and the Birth Room of James VI

Between the Clock Tower and the Banqueting Hall is the Royal Palace, with a curious suite of rooms including Queen Mary's Chamber, where she lived while pregnant in 1566, and a small adjoining room where she gave birth to the future James VI. Fearing a difficult childbirth, Mary had the skull of St Margaret brought to the castle from Dunfermline Abbey for this venerable relic to protect her. This stratagem appears to have had the desired effect: the little prince was born healthy and strong, according to mainstream history at least, and would become James VI when Mary was forced to abdicate the following year. In 1603, he became James I of England also, and would live on until 1625, becoming known as the 'Most Learned Fool in Christendom'. Both the rooms depicted by Phillimore in Edwardian times are still open to the tourists.

In Victorian times, the tour guides at Edinburgh Castle had a startling story to tell: in 1830, a coffin had been found immured in one of the walls of the Royal Palace, which contained the skeleton of a newborn babe, wrapped in a velvet cloth embroidered with the letters 'J. R.'. This sinister discovery would imply that the true child of Mary Queen of Scots had died in infancy, and that James VI was a changeling, introduced into the royal crib with or without the knowledge of Mary Queen of Scots. The mainstream historians have shunned the story as a fabrication invented by the tour guides to astound their credulous Cockney visitors. Various conspiracy theorists have speculated that the Earl and Countess of Mar donated their second son to act the part of the little prince, or that an empty crib had been lowered from the castle using a long rope, to be filled with a healthy child purchased for a few shillings in one of the dens in the Cowgate.

Some research showed that the story of the 'Edinburgh Castle Mystery' had more truth behind it than previously presumed. The Archives of the Society of Antiquaries of Scotland hold some very interesting early documents concerning this mysterious matter. At the meeting on 14 February 1831 an account was by Captain J. E. Alexander, of the 'discovery in the wall of the Palace, Castle of Edinburgh, of the remains of a child, which were wrapped in a shroud of Silk and Cloth of Gold'. Several of the bones were presented to the society, and other bones, as well

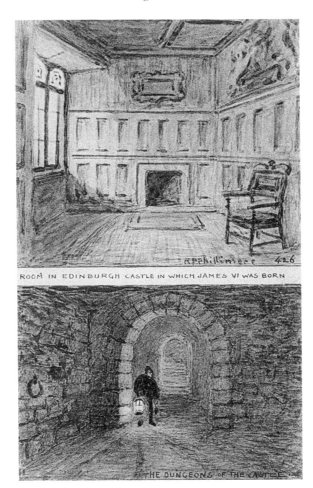

ROOM IN EDINBURGH CASTLE IN WHICH JAMES VI WAS BORN

THE DUNGEONS OF THE CASTLE

as two fragments of the shroud, one of them having the letter 'J' embroidered upon it, were exhibited. In a letter dated 16 July 1831, Sergeant-Major Dingwall, late of the Scots Grey, sent a part of the coffin and some bones to the society, adding the valuable detail that they had been found on 11 August 1830. The 1849 catalogue of the society's museum does not mention either coffin or bones, but instead includes a portion of the shroud in which the remains of the infant had been wrapped, donated by Captain Alexander. This item has since been lost.

Since there is also mention of the mysterious discovery at Edinburgh Castle in a contemporary newspaper, the *Glasgow Courier* of 14 August 1830, and since a certain Mr P. H. M'Kerlie signed an affidavit that as a boy, he had been a witness when the remains had been found in 'the wall above the Messman's room', there is reason to believe that on 11 August 1830, the remains of an infant were really found in the Royal Apartments at Edinburgh Castle. Portions of coffin, shroud and bones were taken as souvenirs by several of the military men, and some were given to the lad M'Kerlie for his private museum; some of these exhibits ended up with the Society of Antiquaries of Scotland, who lost or discarded them long ago. Several of the accounts mention that the shroud was embroidered with the letter 'J' or 'I', although some people thought they could also see a 'G'. Apart from this, there is nothing to link the remains with the future James VI. Of the amateur historians discussing the mystery, some have gone into extravagant discussions of changelings on the throne, but Queen Mary surely must have been aware whether her newborn son was alive or dead, and it is not compatible with what is known of her character that she would willingly have played a role in such a charade. The Edinburgh Castle Mystery is a mystery still.

CASTLE HILL AND LAWNMARKET

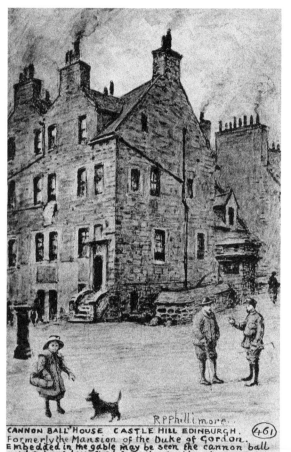

CANNON BALL HOUSE CASTLE HILL EDINBURGH. (461)
Formerly the Mansion of the Duke of Gordon.
Embedded in the gable may be seen the cannon ball
said to have been fired from the castle in 1745.

R P Phillimore.

Cannonball House

The first house on the southern side of Castle Hill, approaching it from the castle, is the large and substantial Cannonball House, so called because a cannonball is embedded in the wall overlooking the Castle Esplanade. Victorian tour guides liked to tell yarns about this cannonball being fired from the castle in some conflict or other – either Cromwell's siege in 1650, the siege conducted in the interest of William of Orange in 1689, or when the castle was held on behalf of George II by Generals Guest and Preston in 1745. As is evident from his card, Phillimore preferred the latter version, further claiming that the Cannonball House had once been the mansion of the Duke of Gordon. This would appear to be wrong, however, since the town house of this duke, wantonly pulled down in the 1880s for the construction of a school, was in fact situated to the south of the Cannonball House.

There is no doubt that the Cannonball House is very old indeed, a dormer window having the inscription '1630'. There were repairs and alterations to the house in Georgian times, and also as recently as 1913. When the house was put up for sale for £2,500 in 1909, there was a good deal of interest in its history, and the antiquary Bruce J. Home read a paper about it before the Old Edinburgh Club. It has been claimed that it was a school for a while, and that it is haunted by a ghostly Victorian schoolgirl. The story of the cannonball embedded in the wall being fired from the castle has been rejected by ballistics experts, who found this quite impossible for technical reasons. Instead, it has been speculated that the cannonball was deliberately put in the wall by engineers, to indicate the dividing line between the civil authority of the city and military regime at the castle, or perhaps rather to indicate the gravitational height of the piped water supply brought from Comiston Hill to the original reservoir on Castle Hill, supplying the Old Town. The Cannonball House is today home to the Contini Cannonball Restaurant, and I was taken there for luncheon some years ago, eschewing the haggis cannonballs on the menu for some excellent lobster Thermidor.

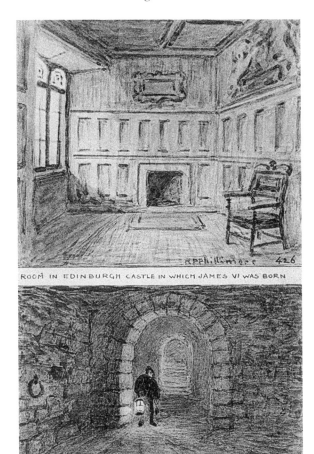

ROOM IN EDINBURGH CASTLE IN WHICH JAMES VI WAS BORN

THE DUNGEONS OF THE CASTLE

as two fragments of the shroud, one of them having the letter 'J' embroidered upon it, were exhibited. In a letter dated 16 July 1831, Sergeant-Major Dingwall, late of the Scots Grey, sent a part of the coffin and some bones to the society, adding the valuable detail that they had been found on 11 August 1830. The 1849 catalogue of the society's museum does not mention either coffin or bones, but instead includes a portion of the shroud in which the remains of the infant had been wrapped, donated by Captain Alexander. This item has since been lost.

Since there is also mention of the mysterious discovery at Edinburgh Castle in a contemporary newspaper, the *Glasgow Courier* of 14 August 1830, and since a certain Mr P. H. M'Kerlie signed an affidavit that as a boy, he had been a witness when the remains had been found in 'the wall above the Messman's room', there is reason to believe that on 11 August 1830, the remains of an infant were really found in the Royal Apartments at Edinburgh Castle. Portions of coffin, shroud and bones were taken as souvenirs by several of the military men, and some were given to the lad M'Kerlie for his private museum; some of these exhibits ended up with the Society of Antiquaries of Scotland, who lost or discarded them long ago. Several of the accounts mention that the shroud was embroidered with the letter 'J' or 'I', although some people thought they could also see a 'G'. Apart from this, there is nothing to link the remains with the future James VI. Of the amateur historians discussing the mystery, some have gone into extravagant discussions of changelings on the throne, but Queen Mary surely must have been aware whether her newborn son was alive or dead, and it is not compatible with what is known of her character that she would willingly have played a role in such a charade. The Edinburgh Castle Mystery is a mystery still.

CASTLE HILL AND LAWNMARKET

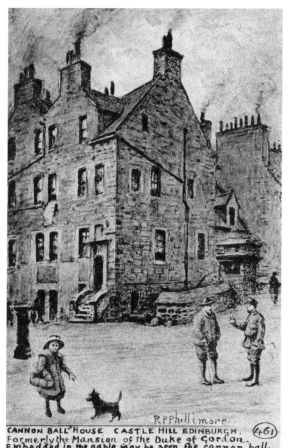

CANNON BALL HOUSE CASTLE HILL EDINBURGH. (461)
Formerly the Mansion of the Duke of Gordon.
Embedded in the gable may be seen the cannon ball
said to have been fired from the castle in 1745.

R P Phillimore

Cannonball House

The first house on the southern side of Castle Hill, approaching it from the castle, is the large and substantial Cannonball House, so called because a cannonball is embedded in the wall overlooking the Castle Esplanade. Victorian tour guides liked to tell yarns about this cannonball being fired from the castle in some conflict or other – either Cromwell's siege in 1650, the siege conducted in the interest of William of Orange in 1689, or when the castle was held on behalf of George II by Generals Guest and Preston in 1745. As is evident from his card, Phillimore preferred the latter version, further claiming that the Cannonball House had once been the mansion of the Duke of Gordon. This would appear to be wrong, however, since the town house of this duke, wantonly pulled down in the 1880s for the construction of a school, was in fact situated to the south of the Cannonball House.

There is no doubt that the Cannonball House is very old indeed, a dormer window having the inscription '1630'. There were repairs and alterations to the house in Georgian times, and also as recently as 1913. When the house was put up for sale for £2,500 in 1909, there was a good deal of interest in its history, and the antiquary Bruce J. Home read a paper about it before the Old Edinburgh Club. It has been claimed that it was a school for a while, and that it is haunted by a ghostly Victorian schoolgirl. The story of the cannonball embedded in the wall being fired from the castle has been rejected by ballistics experts, who found this quite impossible for technical reasons. Instead, it has been speculated that the cannonball was deliberately put in the wall by engineers, to indicate the dividing line between the civil authority of the city and military regime at the castle, or perhaps rather to indicate the gravitational height of the piped water supply brought from Comiston Hill to the original reservoir on Castle Hill, supplying the Old Town. The Cannonball House is today home to the Contini Cannonball Restaurant, and I was taken there for luncheon some years ago, eschewing the haggis cannonballs on the menu for some excellent lobster Thermidor.

Plainstanes Close

No. 94 (today No. 78) Lawnmarket was once home to Plainstanes Close, which was constructed prior to 1780. It was a handsome and picturesque old Edinburgh close, paved with flagstones instead of cobbles. It still existed in 1852 but was lost in the mid-Victorian city improvement schemes; nothing whatsoever remains of it today. Since Plainstanes Close was lost long before Phillimore came to Edinburgh, he is likely to have relied on some old print of it for his postcard. There is a colour plate of Plainstanes Close in Geddie's *Romantic Edinburgh*, from a watercolour by R. Noble, but it does not match Phillimore's perspective of the close. He included a vignette of the poet Robert Fergusson, author of the 'Mutual Complaint of Plainstanes and Causey', although there is nothing to link him with Plainstanes Close.

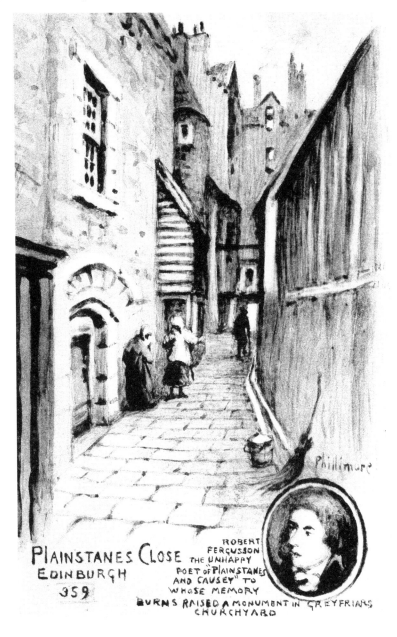

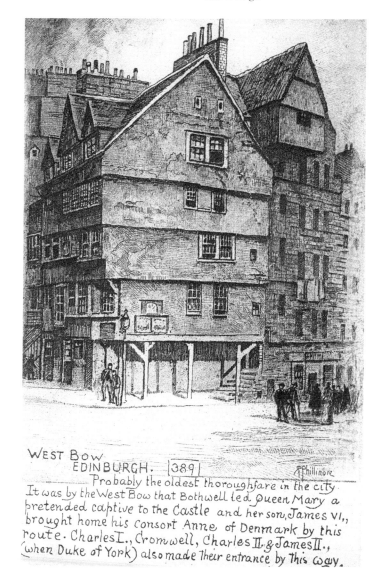

WEST BOW
EDINBURGH. |389|
——— Probably the oldest thoroughfare in the city.
It was by the West Bow that Bothwell led Queen Mary a
pretended captive to the Castle and her son, James VI,,
brought home his consort Anne of Denmark by this
route. Charles I., Cromwell, Charles II. & James II.,
(when Duke of York) also made their entrance by this way.

The Bow-Head Corner House

The West Bow existed already in medieval times, as the historic west gate of the burgh, until the West Port was constructed some time prior to 1509. The West Bow used to be a steep, Z-shaped thoroughfare leading from the Lawnmarket down to the Grassmarket. The house of the warlock Major Weir, executed for unnatural crimes in 1670, was situated in the Upper Bow. A humble dwelling of ancient origin, reached through a narrow pend, it was known as the most haunted house in Edinburgh, and those foolhardy enough to live there were soon driven out by the ghosts. Phillimore's card shows the Bow-Head Corner House, which for many years was an Edinburgh landmark, and one of the finest of the old timber-fronted burgher mansions in the Old Town. With each story extending further than the narrow stone-built ground floor, it seemingly defied the force of gravity. Since the Corner House was wantonly pulled down in a street improvement scheme in 1878, Phillimore must have made use of some old print to paint its likeness. In the same scheme, the Netherbow was merged with the newly constructed Victoria Terrace, and only a short rump remains of the Upper Bow today.

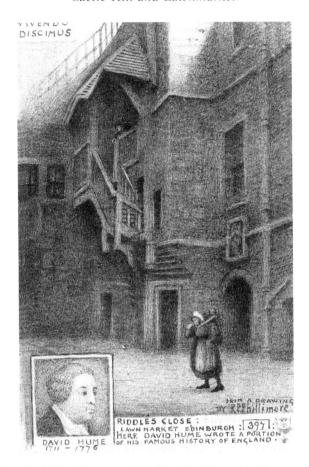

VIVENDO
DISCIMUS

RIDDLES CLOSE :
LAWN MARKET EDINBURGH : 397 :
HERE DAVID HUME WROTE A PORTION
OF HIS FAMOUS HISTORY OF ENGLAND ·

FROM A DRAWING
BY R P Phillimore

DAVID HUME
1711 - 1776

Above and overleaf: Riddles Court and Baillie MacMorran's House

Riddle's Court is named after the wright and burgess George Riddell, who rebuilt the foreland in 1726. As Phillimore noted, the celebrated philosopher David Hume lived in Riddle's Court for a while, with 'a maid and a cat as subsidiaries and a sister for company', as he expressed it. The most famous house in Riddle's Court is that of Baillie John MacMorran, constructed in or around 1590 on the site of an older, ruined building. MacMorran was one of the wealthiest merchants in Edinburgh. In the 1570s, he had been a servant of Regent Morton, and there were murmurations that he had helped to conceal some of the former regent's treasure; other bruits said that he had once exported grain to Spain at a time of dearth.

In 1595, the pupils at the Edinburgh High School rioted since they thought their holidays were not extensive enough. The boys drove out the teachers and barricaded themselves in the school. When Baillie MacMorran was sent to end the rebellion, the boys refused to negotiate a truce. When MacMorran and his men tried to break into the school, using a beam as a battering ram, he was shot in the head by a thirteen-year-old schoolboy and died instantly. The rebellious boys were treated with great lenience since they came from prominent families, and even the boy who had gunned down MacMorran was never punished. Baillie MacMorran's house was inherited by his brother Ninian, and his wife and children were provided for. In 1598, a grand banquet was held here for Ulrik, Duke of Holstein, in the presence of James VI and Anne of Denmark. Baillie MacMorran's house still stands, with some original painted ceilings and other features intact. It is looked after by the Scottish Historic Buildings Trust. A visit to Riddle's Court can be ended at the railings adjacent to Baillie MacMorran's house, through which can be seen the rear of the toilet block of the Quaker Meeting House, which marks the spot of the house of Major Weir, once the most haunted in Edinburgh.

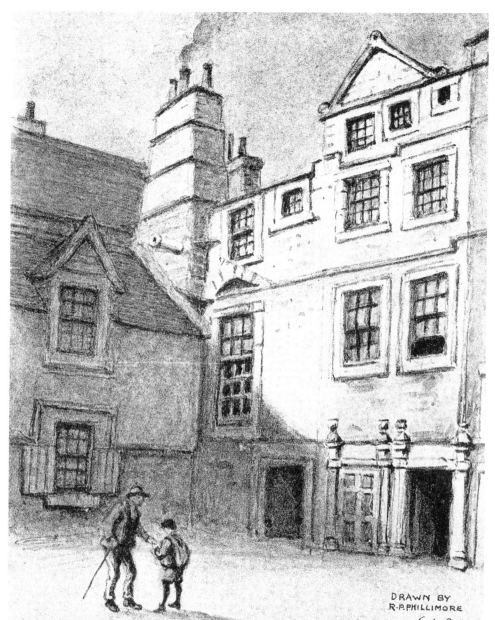

DRAWN BY
R.P.PHILLIMORE
643

Bailie John MACMORRAN'S HOUSE, RIDDLES CLOSE, EDINBURGH.
Here in 1593 the Bailie entertained James VI. and his Queen
Anne of Denmark at a banquet.
Macmorran came to a tragic end in 1595 at the hands
of a school boy, William Sinclair, son of the Chancellor
of Caithness, when a holiday having been refused, the
pupils of the High School took possession of the school
and provided themselves with arms. Macmorran was
shot dead by Sinclair. By the influence of the Chancellor
the crime was pardoned on payment of a heavy fine.

Milne's Court

This large close off the Lawnmarket was
constructed between 1684 and 1688 by the
master mason Robert Milne (or Mylne). It
was, and still is, an open square, with tall
houses on all four sides. It was popular in
the eighteenth century: David Hume moved
here from Riddle's Court, and Boswell
entertained Samuel Johnson here, before the
great lexicographer set out for his tour of the
Western Isles in 1773. Milne's Court went
steadily downhill in Victorian times, and the
decay continued well into modern times,
with the once elegant open square becoming
a slum. In the end, it was decided to perform
a major restoration and part rebuilding of
the old close, and to develop it into student
housing. This scheme was widely praised
among the conservationists, and a plaque
on one of the houses announces that Milne's
Court won the Saltire Society Award for
Reconstruction in 1971.

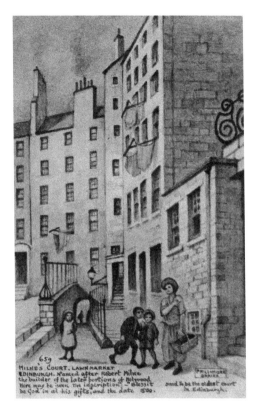

James Court

This large court off the Lawnmarket was also
known as Brownhill's Court in olden times. It
used to have four entries, of which three remain
today: the West, Mid and East Entries. James
Court was constructed in 1725–27 by the wright
James Brownhill. It flourished in the eighteenth
century, and when the philosopher David Hume
decided to move out of Riddle's Court, he took
a flat in James Court instead. This flat was later
taken over by another man of letters, James
Boswell, but he moved to another, larger flat
on two floors, where he entertained Samuel
Johnson in 1773, when the great lexicographer
came to Edinburgh to start his expedition to the
Western Isles. In Victorian times, James Court
became increasingly dilapidated: some buildings
perished in a fire in 1857, and others were
reconstructed in the 1890s. It survives to this
day, although Hume and Boswell would hardly
have recognised it.

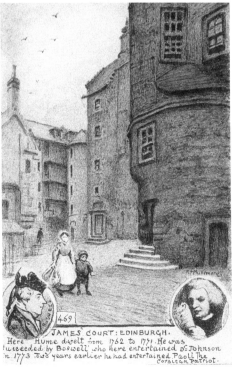

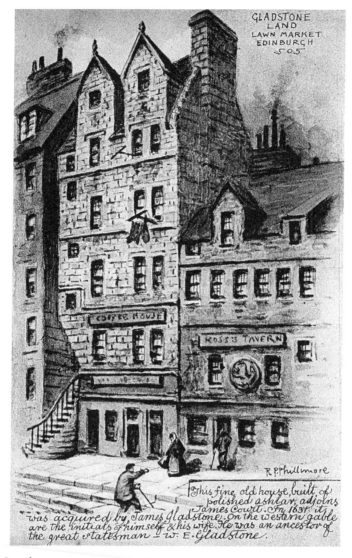

Gladstone's Land

This celebrated Lawnmarket tenement was constructed in or around 1501. In 1617, it was bought by the merchant Thomas Gledstanes, who set out to rebuild and extend the house. The ground floor contained two small shops, or luckenbooths; there was a communal staircase, from which a number of flats could be accessed. As time went by, the finances of Thomas Gledstanes deteriorated and he had to relinquish parts of the house, but at his death in 1651, his son William took it over. It remained just another Lawnmarket tenement for centuries to come, increasingly dirty and neglected. When depicted by Phillimore in Edwardian times, it housed a coffee house and a tavern; when photographed in 1920, it was home to Ramage's Dairy and Robbie Burns' Bar. In 1934, the National Trust for Scotland was made aware of the precarious state of the old house, and through a generous donation, it was purchased and restored. During restoration, some curious features were discovered including some of the original painted ceilings; since Gladstone's Land was opened as a museum in 1980, they can today be admired by all and sundry. The original ground-floor luckenbooth is still operational – the only one in Edinburgh – selling knitwear and Caledonian mementoes to the tourists.

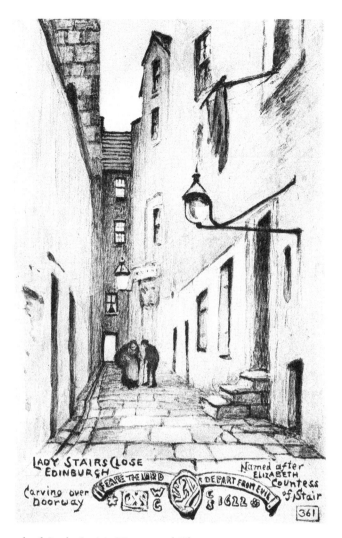

LADY STAIRS CLOSE
EDINBURGH

Named after
ELIZABETH
Countess
of Stair

Carving over
Doorway

FEARE THE LORD · DEPART FROM EVIL

W·G C·S 1622

361

Above and overleaf: Lady Stair's House and Close

The building today known as 'Lady Stair's House' was built in 1622 by the wealthy merchant Sir William Gray of Pittendrum, whose coat of arms can still be seen above the main entrance. Elizabeth, Dowager Countess of Stair, moved into the house in 1720, and she gave her name to both the building itself and the narrow close from the Lawnmarket through which it was accessed. When the house was advertised for sale in 1825, it was purchased by the brush maker John Russell, whose family lived here until 1895. Since they had not given the old house the maintenance it deserved, it was in a dilapidated condition and risked demolition. However, some Edinburgh antiquaries managed to persuade Lord Rosebery to purchase and restore the house. Work was finished in 1897, but his lordship faced criticism from the purists, who thought he had 'improved on' the old house and added some unnecessary features. Indeed, a print of the original house, kept on display today, shows that many liberties had been taken during the restoration. Lord Rosebery gave the house to the City of Edinburgh in 1907 for use as a museum, and it is today the Writer's Museum, containing exhibits about Robert Burns, Sir Walter Scott and Robert Louis Stevenson. Burns' writing desk and a plaster cast of his skull are on prominent display, as are Scott's chessboard and meerschaum pipe, young Stevenson's toy theatre, and a cabinet made by the notorious Deacon Brodie, once owned by the Stevenson family.

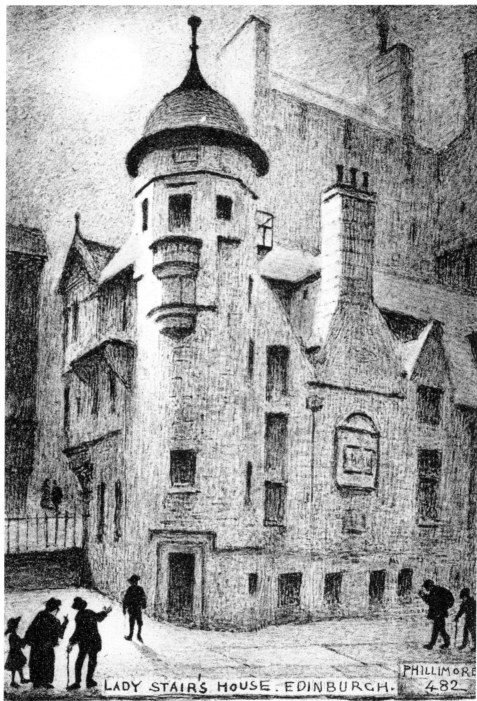

LADY STAIR'S HOUSE. EDINBURGH. 482

PHILLIMORE

Built in 1622 by Sir William Gray of Pittendrum. It was occupied by the Dowager Lady Stair early in the 18th century. Her story was utilized by Scott in "My Aunt Margaret's Mirror". It was restored by Lord Rosebery in 1907. And opened by him as a museum Dec 5th 1913.

THE HIGH STREET

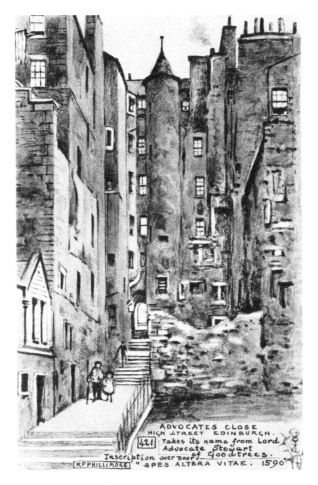

ADVOCATES CLOSE
HIGH STREET EDINBURGH.
421 Takes its name from Lord
Advocate Stewart
Inscription over Door of Goodtrees.
R P PHILLIMORE "SPES ALTERA VITAE. 1590"

Above and overleaf: Advocates' Close

This High Street close is one of the oldest in Edinburgh and believed to date back to the 1540s. In the 1590s, it was known as Clement Cor's Close, from a prominent merchant; later names included Home's Close and Cant's Close. After Sir James Stewart of Coltness, provost of Edinburgh in 1648–49 and 1658–59, had purchased a house in the close, it was renamed Provost Stewart's Close. It was his son, Sir James Stewart of Goodtrees, Lord Advocate between 1692 and 1709, that gave the close its present name. He was a distinguished politician and lawyer, a supporter of presbytery, and a great enemy of the house of Stuart. He died at his house in Advocates' Close, from complications to severe gout, in May 1713. The house remained in the Stewart family until put up for sale in 1769. For the locals, Advocates' Close is a useful shortcut from the High Street to Cockburn Street; for clumsy and unfit tourists, the steep and narrow close, with its worn and uneven steps, can be the site of heavy and undignified falls. In 2010s, it was restored and rebuilt following longstanding neglect, a scheme that was given the Best Building in Scotland award in 2014.

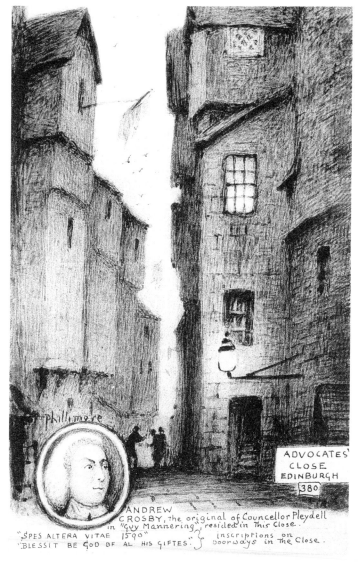

Phillimore

ANDREW CROSBY, the original of Councellor Pleydell in "Guy Mannering", resided in This Close.

"SPES ALTERA VITAE 1590"
"BLESSIT BE GOD OF AL HIS GIFTES." } Inscriptions on Doorways in The Close.

ADVOCATES' CLOSE EDINBURGH 380

Advocates' Close has a ghost story of its own, emanating from the prolific Edinburgh 'ghost tour' industry. It is historical fact that in 1689, a wealthy man named John Chiesley wanted to divorce his wife, with whom he had ten children. When Sir George Lockhart, the Lord President of the Court of Sessions, ordered him to pay her a substantial sum of money, Chiesley was enraged. One evening, he followed Sir George to his home and gunned him down with a pistol. Chiesley, who made no attempt to escape, was tortured in prison, and his right arm was severed from the body before he was executed. The ghost of 'Johnny One-Arm' was seen more than once, roaming the narrow closes of the Royal Mile. In 1965, a skeleton lacking one arm was found when an old cottage was renovated in Dalry, and by some stratagem or other, it was determined that this was the remains of John Chiesley. The bones were given a decent burial, and the haunting ended, except the disembodied arm still haunts Advocates' Close, grabbing at passers-by. Rationalists have objected that it was in fact just Chiesley's right hand that was cut off, and that Sir George was murdered outside his house in Old Bank Close. The observations of the one-armed ghost and the disembodied arm are of a nebulous quality, and intended for the consumption of the more credulous of the Edinburgh tourists.

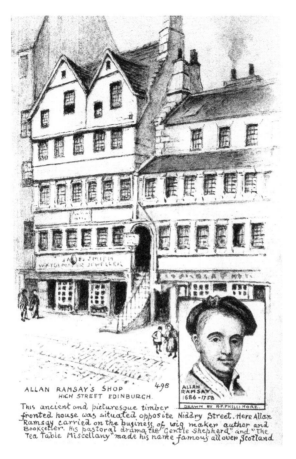

ALLAN RAMSAY'S SHOP
HIGH STREET EDINBURGH.

ALLAN
RAMSAY
1686-1758

DRAWN BY R.P.PHILLIMORE.

This ancient and picturesque timber fronted house was situated opposite Niddry Street. Here Allan Ramsay carried on the business of wig maker author and Bookseller. His pastoral drama the "Gentle Shepherd" and "The Tea Table Miscellany" made his name famous all over Scotland

Allan Ramsay's Shop

Allan Ramsay, the celebrated Edinburgh poet, playwright and publisher, was born in Leadhills, Lanarkshire, in 1684. He received a decent education and became interested in Scottish folklore and poetry at an early age. In 1701, he was apprenticed to a wigmaker in Edinburgh, and opened his own business in due course. He was admitted a burgess of Edinburgh in 1710. Allan Ramsay made his reputation as a bookseller, author and poet, operating from a large town house situated on the northern side of the High Street, opposite where Niddry Street is today. He was a very felicitous poet, and an active Edinburgh clubman with many literary friends. His house, where he had his bookshop, became a well-known landmark in the High Street, as Allan Ramsay's literary fame grew steadily during the 1720s.

In 1733, Allan Ramsay bought some ground on Castlehill, and had a house, which he called the Goose Pie, constructed there. In early 1739, he put his town house and shop up for sale. Allan Ramsay's wife died in 1743, and his own health began to fail in the 1750s, after he had developed scurvy of the gums and jaw. He died in 1755, and is buried at Greyfriars, where there is a fine monument to him at the south side of the kirk. He is also depicted in a relief on the Scott Monument, and a fine statue of him stands in the West Prince's Street Gardens. His old house in the High Street met with evil times, however: it became increasingly dilapidated in Victorian times, and the historic house was wantonly demolished in 1899. Thus Reginald Phillimore was not in time to see it personally and had to reconstruct it in his postcard, most probably from an old print. The patriotic Allan Ramsay would hardly have appreciated that the Edinburgh Hilton today stands on the site, but at least the downstairs shop advertises expensive kilts and other Caledonian sartorial paraphernalia.

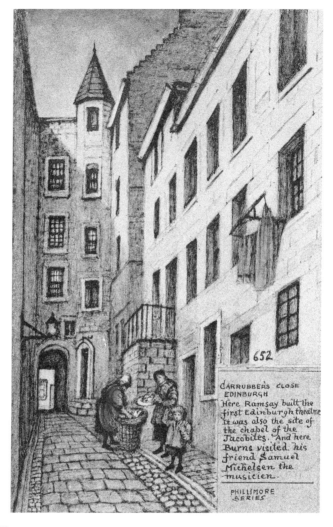

652

CARRUBBERS CLOSE
EDINBURGH
Here Ramsay built the
first Edinburgh theatre
It was also the site of
the chapel of the
Jacobites. And here
Burns visited his
friend Samuel
Michelsen the
musicien

PHILLIMORE
SERIES

Carrubber's Close

This ancient High Street close, situated right next to Allan Ramsay's old house, is likely to have received its name from William de Carriberis, a burgher who lived here in the 1450s. Since it contained one of the few remaining Episcopalian chapels after 1688, it was known as a stronghold for the Jacobites. Just below St John's Chapel stood Clam-Shell Land, where Robert Burns was often entertained by the Master of Ainslie, the celebrated architect and land surveyor. In 1736, Allan Ramsay made a bold attempt to open a theatre in a building he had constructed in Carrubber's Close, but the authorities soon closed it down. The building, renamed St Andrew's Chapel, stood for many years, and was used for lecturing purposes by the eccentric Dr James Graham, who believed that disease was caused by too-much heat in the body. Apart from a disastrous fire in 1758, in which four tenements burned down with considerable loss of life, Carrubber's Close remained more or less unchanged in Victorian times. Indeed, Jane Stewart Smith wrote that, 'The close has suffered little from modern alterations, and is both quaint and picturesque.' However, Carrubber's Close suffered badly when Allan Ramsay's house was demolished in 1899, and the large hotel was erected on the site. It has an archway marked '1899' facing the High Street, but no old or interesting buildings remain. It is used for storage of the refuse bins of the Edinburgh Hilton, and is a disgusting sight indeed, in such a prominent position.

The Town Mansion of the MOUBRAY HOUSE 1394
Moubrays of Barnbougle High Street EDINBURGH.
Dates from 15 century
John Moubray Loird of Cammo took a leading part in
Measures for abatement of the plague in 1645.

Moubray House

Next to John Knox's house in the High Street stands ancient Moubray House, originally constructed by Robert Moubray in 1477, although the majority of the fabric in the present-day structure is seventeenth century in origin. After being inhabited by the prosperous Moubray family for quite some time, the house became a tavern in the eighteenth century, with a bookshop on the ground floor. Daniel Defoe lived here when he edited the *Edinburgh Courant*. In Victorian times, the house became increasingly dilapidated until it was purchased by the Cockburn Association in 1910, for restoration. It was thought a very curious survival of Edinburgh architecture, with its old-fashioned forestairs leading up to the first floor. In recent years, Moubray House was purchased by the American millionaire Debra Stonecipher, who commissioned the building to be restored and updated without regard to cost. A fine painted ceiling was unearthed, and a plaster ceiling moulded with exotic fruits and flowers restored. In 2012, this public-spirited American lady gifted Moubray House to Historic Scotland; it was to be handed over within the next ten years and opened up to the public.

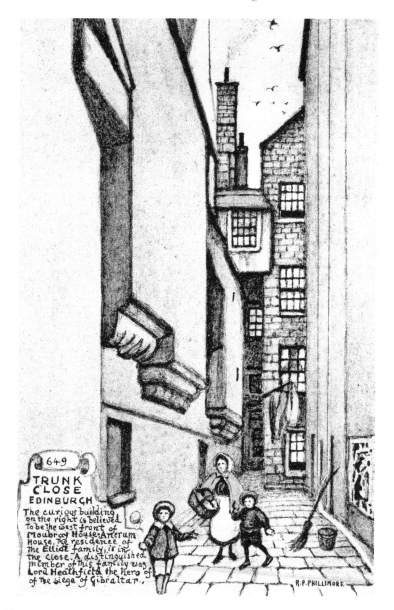

649

TRUNK
CLOSE
EDINBURGH

The curious building
on the right is believed
to be the west front of
Moubray House. Anerum
House, The residence of
the Elliot family, is in
the Close. A distinguished
member of this family was
Lord Heathfield the hero of
of the siege of Gibraltar.

R.P.PHILLIMORE

Trunk's Close

Right next to Moubray House is the narrow alley Trunk's Close, depicted by Phillimore looking towards the High Street; from this perspective, it has barely changed at all since then. The name has been suspected to be a corruption of 'Turing's Close', since the burgess John Turing is recorded to have owned property here in 1478, which was inherited by his son Andrew ten years later. Another name for it was 'Andrew Bryson's Close', from a prominent seventeenth-century inhabitant. The first edition of the *Edinburgh Review* was printed at Trunk's Close in 1802 by Archibald Constable. Today Trunk's Close is home to the headquarters of the Cockburn Association, working for the preservation of historic Edinburgh. The close has been extended to the rear, where a modern building houses the Scottish Book Trust. From a small artificial lawn adorned with a monument to the Edinburgh philanthropist and polymath Sir Patrick Geddes, erected in 2012, the rear elevations of Knox's House and Moubray House can be admired.

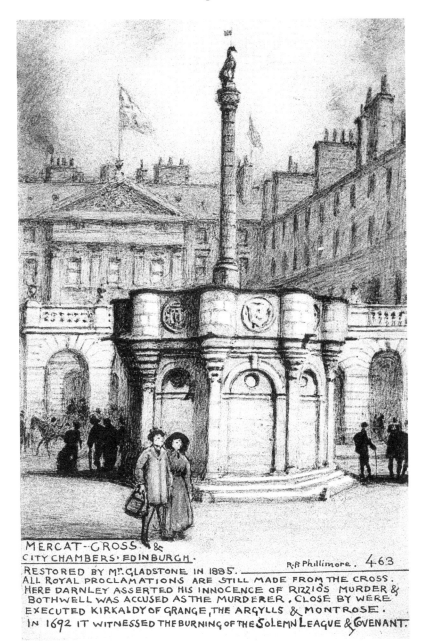

MERCAT-CROSS & CITY CHAMBERS·EDINBURGH. R·P·Phillimore. 463
RESTORED BY MR. GLADSTONE IN 1885. ALL ROYAL PROCLAMATIONS ARE STILL MADE FROM THE CROSS. HERE DARNLEY ASSERTED HIS INNOCENCE OF RIZZIO'S MURDER & BOTHWELL WAS ACCUSED AS THE MURDERER. CLOSE BY WERE EXECUTED KIRKALDY OF GRANGE, THE ARGYLLS & MONTROSE. IN 1692 IT WITNESSED THE BURNING OF THE SOLEMN LEAGUE & COVENANT.

The Mercat Cross

A mercat cross is the Scottish name for a market cross, signifying that the city or town in question has been granted the right to hold a regular market or fair; there are 126 of them in total, scattered all over the country. The Mercat Cross of Edinburgh was first referred to in 1365. It was used for important proclamations, and also as a site for the punishment of serious crimes. In 1565, Sir John Tarbet was tied to the cross and pelted with eggs for saying Mass, something that had been outlawed by the Scottish Parliament five years earlier. In 1584, the arsonist Robert Henderson was burnt alive at the cross. In 1600, following the failure of the Gowrie conspiracy, John Earl of Gowrie and his brother Alexander Ruthven were hanged and quartered at the Mercat Cross.

In 1617, the Mercat Cross was taken down and re-erected on a new substructure lower down the High Street. The Marquis of Montrose was executed here in 1650. In 1688, when the mob had stormed James VII's private chapel and torn down all its woodwork, it was ceremoniously burnt at the Mercat Cross, along with an effigy of the Pope. In 1745, Charles Edward Stuart had his father proclaimed James VII and himself regent at the cross. After his defeat at Culloden, the Jacobite colours were solemnly burnt there. In 1756, the Mercat Cross was demolished, not because of its role in the Jacobite Rebellion but because it obstructed the traffic in the busy High Street. Lord Somerville preserved the capital and part of the shaft, which he erected as a garden feature at Drum House, Gilmerton.

In 1866, the Edinburgh worthies belatedly regretted the wanton demolishment of the historic Mercat Cross. It was rebuilt, incorporating the pieces from Drum House, to the north of St Giles's, where it would not impede the traffic. In 1885, Prime Minister Gladstone had a new substructure designed, and the cross was moved to its present position. George V made a proclamation at the cross in 1910. In 1970, the Edinburgh Corporation replaced the shaft of the Mercat Cross, since its stability was in danger due to the decay of some of the stones, preserving the unicorn finial, the capital and two pieces of one of the old shaft stones.

The Parliament Hall

While hordes of tourists pay their respects to the new Scottish Parliament at Holyrood, known as the 'modern carbuncle' by the purists, it is not generally known that the original Scottish Parliament Hall still remains today, looking very much unchanged since depicted by Phillimore in Edwardian times. The original parliament building was constructed in 1632, and has today been incorporated into the complex of legal buildings around Parliament Square. It shares its entrance at No. 11 with the Court of Sessions. After passing the ubiquitous security control, it is today possible to see the Parliament Hall, which is devoid of tourists since it is nowhere advertised, although some advocates sit in the benches discussing their cases. There is a magnificent original oak hammer beam roof, plentiful stained glass depicting an archaic legal scene and many armorials, and statues of various legal luminaries of yesteryear.

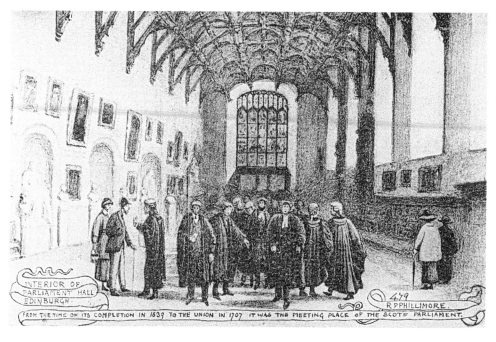

INTERIOR OF PARLIAMENT HALL EDINBURGH · 479 R P PHILLIMORE.

FROM THE TIME OF ITS COMPLETION IN 1639 TO THE UNION IN 1707 IT WAS THE MEETING PLACE OF THE SCOTS PARLIAMENT.

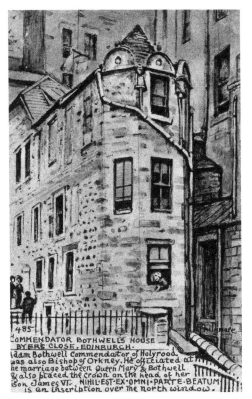

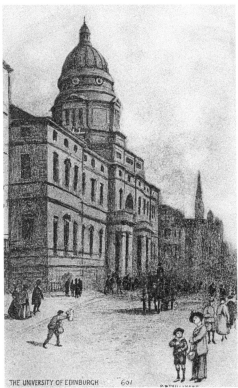

Above left: Commendator Bothwell's House, Byres Close

Adam Bothwell (c. 1527–93) was an influential Scottish clergyman, judge and politician, serving as Bishop of Orkney and Commendator (Abbot) of Holyrood Abbey. He conducted the ceremony of marriage between Mary Queen of Scots and the Earl of Bothwell, and crowned the infant James VI. After the Reformation, he converted to Protestantism, and was thus able to retain his various offices. There has long been a tradition that Adam Bothwell had a house in Byer's (now Byres) Close, off the High Street; which is still standing, although it can today be seen clearly only from nearby Advocates Close. Commendator Bothwell's house was later occupied by Sir William Dick of Braid, once Provost of Edinburgh. It later hit hard times and was for many years used as a warehouse by Messrs. Clapperton & Co. Some later historians have tended to doubt the association of this house to Commendator Bothwell altogether, suggesting that it was in fact constructed long after his death in 1593.

Above right: University

The university building on South Bridge is not on the High Street, but since it is only a short walk away, it is included in this section. The New College, as it was originally called, was planned by Robert Adam after a subscription had been made in 1789. It would replace some dilapidated university buildings, and provide modern teaching headquarters, complete with lodgings for some of the professors, academic halls and lecture theatres. Due to war and strife, it was not completed until 1827, the dome with the Figure of Youth being added in 1887 to finish off Adam's original design. The eastern façade of the university, as depicted by Phillimore in Edwardian times, has a somewhat forbidding aspect, but the interior of the building is very attractive, including the large central quadrangle. The Old College, as it is known today, is home to part of the university administration, to the University of Edinburgh School of Law and to the Talbot Rice Gallery.

MONUMENT TO THE GREAT UNREAD

Opposite: Sir Walter Scott's House

Walter Scott was born in College Wynd, Edinburgh, in 1771. His family was well-to-do and he received a good university education, becoming a solicitor. From an early age, he showed a liking for literary pursuits, and an equally strong fondness for Scottish history and ethnology. As a young man, he had lived in the family home at No. 25 George Square (which still stands), but he moved out after his marriage to Charlotte Carpenter in 1797. In 1802, he moved into the comfortable town house at what is today No. 39 North Castle Street with his family. In 1814, he published his first novel *Waverley*, a tale of the Jacobite rising of 1745, and he would keep producing both poetry and prose for many years. Having published his first novel anonymously, he became known as 'The Author of *Waverley*', *The Great Unknown* or *The Wizard of the North*, but his true identity soon became an open secret. His best-known novels include *Guy Mannering*, *Ivanhoe*, *Kenilworth* and *Quentin Durward*. In 1818, he was instrumental in recovering the Honours of Scotland, which had been hidden away at Edinburgh Castle, and was rewarded with a baronetcy by the grateful Prince Regent. He spent much time and money planning and erecting Abbotsford, his grand country house south of Edinburgh.

In the banking crisis of 1825, the Ballantyne printing business, whose debts Sir Walter had secured, collapsed, and he was facing bankruptcy. Determined to write his way out of debt, he managed to persuade his creditors to place his house and income in a trust, and redoubled his literary endeavours. His novels were issued in many editions and widely translated abroad. He had to give up the house in North Castle Street in 1826, but remained creative for years to come, until he suffered a series of strokes and died of typhus in 1832. He is buried at Dryburgh Abbey in the Scottish Borders. Sir Walter was still in debt by the time of his death, but the continued sale of his books soon ensured his discharge. Phillimore was not the only postcard artist to depict the great Scottish literary lion's house at No. 39 North Castle Street. The house still stands, in excellent order, and still appears to be a family home, although the lower ground floor is today the flat No. 39a and no longer part of the main house.

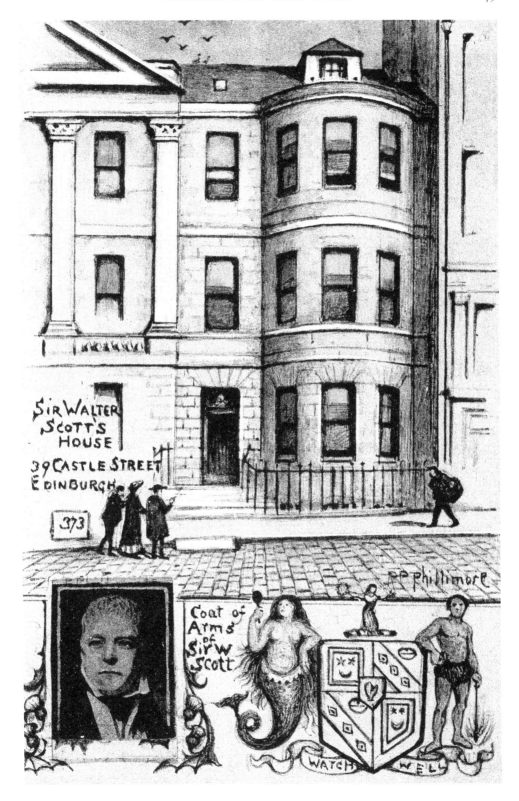

Sir Walter
Scott's
House

39 Castle Street
Edinburgh

373

Coat of
Arms
of Sir W
Scott

RP Phillimore

WATCH WELL

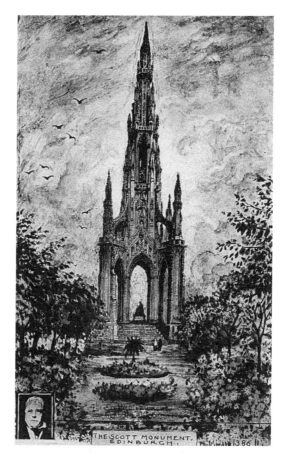

THE SCOTT MONUMENT.
EDINBURGH.

Scott's Monument

Since Sir Walter Scott was very highly thought of in Edinburgh at the time of his death, there was immediate enthusiasm to construct a monument celebrating the city's great literary personage. A design competition announced in 1836 had fifty-four entrants, the winner of which was the draughtsman George Meikle Kemp. The foundation stone was laid at the selected site in Princes Street Gardens in August 1840, and such was the veneration for *The Great Unknown* that the day was observed as a public holiday in Edinburgh. Work on the monument continued apace, and although Kemp died after falling into the Union Canal during heavy fog, his brother-in-law William Bonnar supervised the completion of the monument in 1844. A marble statue of Sir Walter was added in 1846, and a series of statues depicting characters from his novels were later added.

The literary reputation of Sir Walter Scott has fallen rapidly in modern times, and today he is only read by children who have seen *Ivanhoe* on television and by the occasional determined literary historian – *The Great Unknown* has become the 'Great Unread'. Still, Sir Walter remains the only author who has had a railway station named after him, as well as the recipient of the largest monument ever dedicated to a writer. Exceeding 200 feet in height, the Scott Monument affords brilliant views over Edinburgh and beyond. There is a small museum room celebrating his work and plenty of viewing galleries; the stairs to these galleries are uncommonly steep and narrow, to the detriment of the elderly, obese and unfit. The Monument in London became a suicide hotspot soon after its completion, and after six people had destroyed themselves, it had to be surrounded with a mesh cage to prevent any further carnage. The Victorians seem to have treated Scott's Monument more decorously, although a desperate clergyman committed suicide from there in 1951, and there were two further distressing suicides in 2013 and 2016, in front of many witnesses.

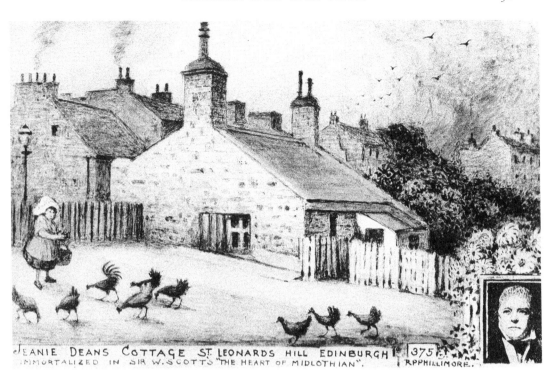

JEANIE DEANS COTTAGE ST LEONARDS HILL EDINBURGH 375
IMMORTALIZED IN SIR W. SCOTTS "THE HEART OF MIDLOTHIAN". RP PHILLIMORE.

Jeanie Deans' Cottage

In 1818, Walter Scott published *The Heart of Midlothian*, whose improbable plot involves the young woman Jeanie Deans, who travels to London to petition the queen after her sister had been unjustly convicted of murdering her own child. This was a time when Scott could do nothing wrong: the book became a great success, and the figure of the religious and upstanding Jeanie Deans a household name. She would give the name to several pubs through Scotland, a number of ships and locomotives, an opera and a play, a hybrid rose and an antipodean potato. Jeanie's statue is on prominent display at the Scott Monument.

Somewhat mysteriously, a low and rustic cottage at the southern end of St Leonard's Bank, near Holyrood Park, was known as 'Jeanie Deans' Cottage' for many years. This cottage stood at the time of Kincaid's Map of 1784, and it was called a Herds Cottage on Kirkwood's map of 1821. The name 'Jeanie Deans' Cottage' was established in 1860, and probably well before that date. It is true that Jeanie's father in the novel was said to live near Holyrood Park, but otherwise there is nothing to connect the wholly fictitious heroine with this unprepossessing little cottage. Still, the name stuck: the cottage was pointed out to Prince Leopold and Princess Beatrice in 1872, as being immortalised in Scott's great novel. Edward Coventon, for many years inspector of Holyrood Park, died at the cottage in 1883.

Jeanie Deans' Cottage remained inhabited, as a park-keeper's house, until the 1950s, but in the end, since no person wanted to live there, it was demolished in 1965. Most of the stones were made use of to form an island for nesting birds in Duddingston Loch. Since the houses on the other side of St Leonard's Bank are still standing, it is possible to pinpoint the exact location of the cottage from Phillimore's postcard. Part of its front wall still stands, as a boundary to Holyrood Park. On the way back from my pilgrimage to the former site of Jeanie Deans' Cottage, I stopped for some refreshments at the 'Jeanie Deans' Tryste' public house at St Leonard's Hill, a late Victorian pub that doubtlessly got its name from the cottage nearby.

ST GILES' CATHEDRAL

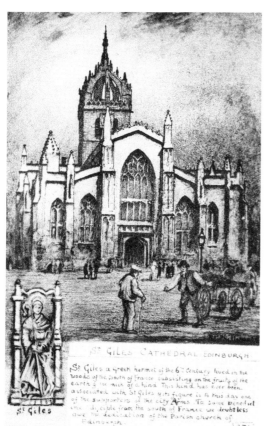

Above left and right: The Cathedral and Stevenson's Monument

St Giles' Cathedral, also known as the High Kirk of Edinburgh, has been the capital's principal place of worship for centuries. The earliest church on the site is likely to have been founded in the early twelfth century, under the reign of David I. After a fire in 1385, the church was extensively rebuilt. After a period of decay in the 1700s, when the church was subdivided into different areas, one of them a police station, and surrounded by shops or luckenbooths built against its walls, action was taken to restore it to its former glory. The luckenbooths and other ramshackle buildings surrounding the church were cleared away, its crumbling walls rebuilt, and the subdivisions removed from the interior. Today, St Giles's Cathedral is a particularly attractive place of worship, with its fine stained-glass windows and elegant monuments, particularly those to the Marquis of Argyll and his rival the Marquis of Montrose. Phillimore depicted the church seen from the west, with a vignette about the original St Giles, a Greek hermit whose only companion was a hind. Another of his cards shows the monument to Robert Louis Stevenson, showing the author smoking a cigarette and reading a book. It is far from the most impressive monument in the church, and Phillimore's card is of a corresponding quality.

THISTLE CHAPEL:
ST GILES CATHEDRAL EDINBURGH 470
R.P.PHILLIMORE

The Thistle Chapel

A much more felicitous Phillimore card shows the exterior of the Thistle Chapel. The Order of the Thistle was founded by James VII in 1687, and finally established by Queen Anne in 1703. Second only to the Garter with regard to prestige and exclusivity, it remains one of the most ancient and noble of all chivalric orders, and Scotland's own. The Thistle Chapel is a modern addition to St Giles', finished as late as 1911 in an elegant Gothic style. There are just sixteen Knights of the Thistle, and a variable number of royal members; the heraldic devices of each current knight is displayed on the stalls, and the coats of arms of the deceased members are also on display. Over the years, a large proportion of the knights have come from the hereditary high nobility, although soldier and author Sir Fitzroy Maclean and former Prime Minister Alec Douglas-Home are exceptions to this rule. When Britain's greatest Admiral of the Second World War, Sir Andrew Cunningham, Viscount Cunningham of Hyndhope, became a Knight of the Thistle; the Chancellor of the Order, the Earl of Mar and Kellie, wrote to congratulate him, recommending him second-hand robes – 'Get them off a dead knight'.

Sunday 21st July 1637 ranks as one of the memorable dates in Scottish History. It was on this day that the new Service Book was appointed to be read in St Giles. The two archbishops with several suffrigans, the Lords of Privy Council & the Lords of Session were present to give solemnity to the occasion. But when the Dean proceeded to read the service there arose such an uncouth noise & hubbub that not any one could either hear or be heard It was in vain that Archbishop Spottiswoode endeavoured to allay the tumult and the service closed amid uproar and confusion. It was on this occasion that Jenny Geddes, an old woman who kept a green grocer's stall in the High Street is said to have flung the stool on which she had been sitting, at the Dean's head.

Opposite: Jenny Geddes and her Stool

One of the most extraordinary stories in the annals of St Giles' Cathedral is that of Jenny Geddes' stool. In 1637, Charles I and Archbishop Laud wanted to impose Anglican services on the Church of Scotland, introducing a new prayer book. When this book was first read from by Dean Hannay on Sunday 23 July 1637 from the pulpit of St Giles', it is said that a woman named Jenny Geddes, said to have been a street-seller or market trader, threw her stool at his head, exclaiming 'De'il gie ye colic, the wame o'ye, fause thief, daur ye say Mass in my lug' (The Devil give you colic in your stomach, false thief, dare you say Mass in my ear). This was the start of a regular tumult, with the rowdy congregation throwing bibles, stools, sticks and stones. When the rioters were ejected, they hammered on the door and threw stones at the windows. This incident triggered full-scale opposition to the new prayer book, leading to the Civil War.

There is no doubt that stools were thrown at St Giles' on 23 July 1637, and that a number of women were among the rioters, yet doubts have remained whether Jenny Geddes was a historical person. One contemporary account names the stool-thrower as 'Jane Gaddis', but another gives her name as Barbara Hamilton, and others just say that an obscure old woman was the instigator of the riot. A poem from the 1730s says that:

> So – when a scolding woman mad is
> She's called, e're since, a JANNY GEDDES

Phillimore's postcard showing Jenny Geddes' stool is drawn from life, since what is purported to be the original four-legged folding stool was donated to the Museum of the Society of Antiquaries of Scotland by a certain Joseph Watson in 1818. It is certainly very old, and has the date '1565' carved into it; it is likely to be a folding stool of the type made use of in churches where the central space was without seating, yet no solid evidence links it with the elusive Jenny herself. A plaque to the memory of Jenny Geddes was erected at St Giles' in 1886, and a sculptured three-legged stool by Merilyn Smith was added in 1992. After seeing them, the reader should proceed to the National Museum of Scotland nearby, where the purported stool of Jenny Geddes is to be seen in the Scottish Galleries, looking very much like when it was drawn by Phillimore in Edwardian times.

JOHN KNOX AND HIS HOUSE

Opposite: John Knox's House

John Knox was born in Haddington in or around 1513 and studied theology at St Andrews University. Under the influence of the Scottish reformer George Wishart, he became a firm Protestant, and took part in a rebellion in which the Protestants captured St Andrews Castle. French troops had to be called in to retake the castle, and the captive Knox had to serve as a galley slave for nineteen months. After travels in England and the Continent, he came to Edinburgh in 1559 and led the Scottish Reformation from the pulpit of St Giles'. When Mary Queen of Scots returned from France in 1561, there was immediate antipathy between the frivolous queen, who had been brought up in the Catholic faith, and the fanatical Protestant John Knox. After much controversy, Mary was forced to abdicate in 1567, and Knox preached the coronation sermon for young James VI. He was unchristian enough to call for Mary's death, but his advice was not acted upon, and Scotland's tragic queen was instead 'exported' to her enemies south of the border. Although increasingly infirm, Knox lived on until 24 November 1573. There is a lifelike statue of him at St Giles', looking very severe and disgruntled, like if he had just detected some person behaving indecorously in the cathedral.

The house today on show as 'John Knox's House', the ancient corner house at the old Netherbow Port, dates back to 1470, but it was substantially rebuilt in the mid-1500s. From quite an early period, it has been associated with John Knox, and as early as July 1828, the *Edinburgh Evening Courant* referred to it as 'John Knox's House'. During early Victorian times, the house became increasingly dilapidated, and it was little more than a slum tenement; the ground floor was still home to a number of shops, one of them 'John Knox's Tavern'. In 1849, when there was a threat that the crumbling old house would be pulled down, a number of prominent Edinburgh citizens came forward to save it, as did the Church of Scotland. The building was restored and opened as a museum in 1853. Furnished with suitable ancient furniture harvested from other old Edinburgh tenements earmarked for destruction, it would remain a popular tourist attraction for many years to come. In the 1960s, there were again calls for its destruction from 'developers' who wanted the High Street to be widened, but the Lord smote those Philistines and saved John Knox's House.

In late Victorian times, the old house's association with John Knox became a subject of debate when it was discovered that in 1525, the house was owned by a certain Walter Reidpath, and later conveyed by his daughter to her son John Arres. In 1556, his daughter Mariota Arres and her husband, the wealthy goldsmith James Mossman, acquired the house and would remain there until 1572. Since Mossman was a Catholic and a firm adherent of Mary Queen of Scots, he would have been extremely unlikely to have offered his enemy John Knox a roof over his head. Thus the old legend that Knox lived in the house from his arrival in Edinburgh in 1559 until his death in 1573 must be an invention, particularly since research has shown that Knox lived in Warriston Close during part of the 1560s. It is certain that Knox never owned the house, and unlikely that he ever lived there. Although it cannot be conclusively disproven that he stayed there some time in 1573, the ailing reformer would have been unlikely to have chosen a house recently vacated by one of his main rivals. As for Sir James Mossman, as he had become, he was arrested following the surrender of the queen's supporters, dragged from Holyrood to the Mercat Cross, and hanged on 3 May 1573; he was beheaded and his body was quartered, the head being set up on a pike at Edinburgh Castle.

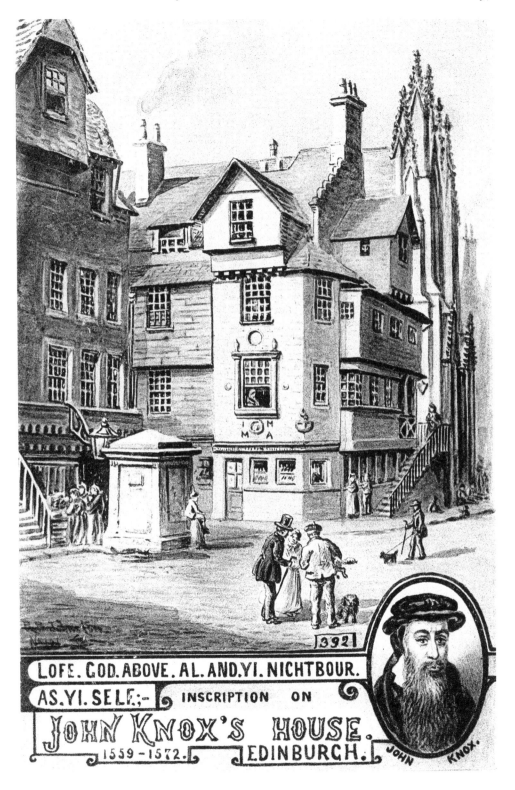

LOFE. GOD. ABOVE. AL. AND. YI. NICHTBOUR.
AS. YI. SELF.;- INSCRIPTION ON
JOHN KNOX'S HOUSE.
1559 – 1572. EDINBURGH.

JOHN KNOX.

JOHN KNOX'S STUDY. 504
JOHN KNOX'S HOUSE 'EDINBURGH'
R.P.Phillimore

In 1561 the Magistrates ordered Dean of Guild to make a warm study for Knox in the house built of "bailies" i.e. to be wainscotted or panelled. It may be that in this study Knox composed the "Confession of Faith" & the "First Book of Discipline" in which at least he had a principal part.

PHILLIMORES HISTORICAL SERIES.

JOHN KNOX'S PULPIT
ANTIQUARIAN MUSEUM, EDINBURGH.

From this pulpit John Knox hurled forth his denunciations of Popery and Prelacy. A well known description of his method of preaching is given by his young friend Melville in the oft quoted words:- "In the opening of his text he was moderate for the space of half an hour, but ere he had done his sermon he was sae active and vigorous that he was like to ding the pulpit in blads and flie out of it."

JOHN KNOX

Above left: John Knox's Study

In late Victorian times, the rooms of John Knox's House were named from the use the great reformer was supposed to have made of them, but this custom has long since been discarded today. In Edwardian times, the 'Knox's Series' of postcards published five cards featuring these rooms, clearly demonstrating that the appearance of the house has changed for the worse since that time, with many attractive features lost. From the appearance of the fireplaces and the wood panelling, it can be established that the first-floor front room was referred to as Knox's audience chamber, and the rear was an unspecified 'room'. On the second floor were his dining room at the front and bedroom at the back. As for the room referred to as 'John Knox's Study', it is clearly the second-floor corner room, as judged from the wood panelling, fire and two windows. Phillimore made a drawing of this so-called study when he visited Knox's house, who rather adventurously linked it with the comfortable study that was ordered to be built for the reformer in 1561.

Above right: John Knox's Pulpit

Phillimore also published a card featuring 'John Knox's Pulpit', which he had seen at the Museum of the Society of Antiquaries of Scotland. It is an ancient oak pulpit, donated to the society by R. Johnston Esq. and described in the 1849 museum catalogue as coming from St Giles' in Edinburgh, where John Knox was minister. Phillimore appears to have had no doubt that this was the very pulpit from which the great reformer had preached, but latter-day commentators have chosen a more cautious approach. The pulpit today shares a gallery at the National Museum of Scotland with Jenny Geddes' Stool and a variety of other objects of religious significance. The description merely states that the pulpit is said to be from St Giles', and Knox's name is no longer mentioned in association with it.

CANONGATE

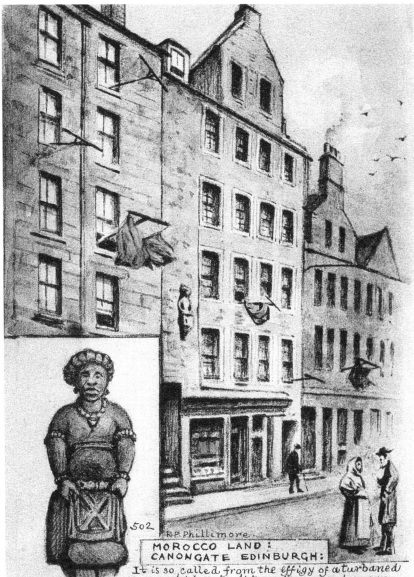

502 R.P.Phillimore.

MOROCCO LAND:
CANONGATE EDINBURGH:

It is so called from the effigy of a turbaned
Moor which is sculptured over the doorway.
The following inscription may also be seen "Miserere mei Domine.
A peccato, probo, debito, et morte subita. Libera me 1·6·18."
Various legends are related as to the origin of the house – one
story is that a young woman of Edinburgh, captured by an African
Pirate was sold into the harem of the Emperor of Morocco. This
enabled her brother to realise a fortune by trade and he built
this house erecting the effigy of the Moor in honour of the Emperor.

Previous: Morocco Land

The tall tenement at No 265–267 Canongate has been known as Morocco Land at least since 1703, and high up on its frontage to the Royal Mile, it is adorned with the statue of a turbaned Moor. There are several stories to explain the name and the statue. Phillimore preferred the version that the house belonged to a merchant whose sister had been captured by pirates, and she later became an influential favourite in the harem of the Emperor of Morocco. She made sure that her brother made a fortune from the trade with Morocco, and such was his gratitude that he erected the statue of a Moor to decorate his house. In 1848, Sir Daniel Wilson told a more elaborate story: a young man named Andrew Gray was sentenced to death for taking part in a riot against Charles I and incarcerated in the Tolbooth. The evening before his impending execution, he broke jail and fled abroad. Years later, he returned to Edinburgh, having made a fortune in Morocco. He married the daughter of the Lord Provost and bought the house that he renamed Morocco Land.

To my mind, both these stories are likely to be Victorian inventions to provide an explanation for the odd and unexpected name of the old house. It is known that in 1653, the merchant Thomas Grey bought the house from the burgess James Whyte, and it is likely that another merchant named John Grey owned the house in 1731, but when the antiquary Charles B. Boog Watson listed the early owners of the house, he found no Andrew Gray. In the sixteenth century, several owners of the house belonged to the Moscrope family, and the close adjacent to it was called Moscrope's Close'in those early days. The statue of the Moor bears the arms of the Smith family of Groathill, but this provides no clue as to its origins. Rationalists have suggested that the statue was intended to signpost a tradesman's place of business, but in that case, it would surely have been put lower down to advertise the shop. It seems reasonable to link the statue with the name of the tenement, which it has born for more than four centuries, but the mystery of Morocco Land is a mystery still. The old house became derelict in the 1930s and 1940s, and there were calls for it to be demolished, but instead it was extensively rebuilt in the 1950s, with the statue of the Moor still in situ today.

The Excise Office formerly in this court. It was for his robbery here that the notorious Deacon Brodie was executed in 1788. CHESSEL'S COURT, CANONGATE EDINBURGH 422

DEACON BRODIE EXECUTED 1788

Chessel's Court

This Canongate close dates back at least to the 1740s, and was named after its constructor, the wright Archibald Chessel. It was a failed attempt to rob the excise office in Chessel's Court that led to the downfall of Deacon Brodie in 1788. When seen by Phillimore in Edwardian times, Chessel's Court was still an attractive old Canongate close, but decay and neglect led to it becoming increasingly dilapidated. Chessel's Court was reconstructed in the 1960s, and an unattractive tenement block from that period today faces the Canongate. Leading through this building, Chessel's Court provides access to a large square with buildings from different periods, which can also be accessed through Pirrie's Close to the west. On the southern side of Chessel's Court is a fine original 'mansion-style' tenement block, and to the western side two tenement blocks dating back to the 1770s; all of these buildings were sympathetically restored in 1963–64.

Above left: Old Playhouse Close

The Upper and Under Playhouse Closes were constructed to provide access to Edinburgh's earliest playhouse, the Canongate Theatre, which opened in 1747. It is the Under Playhouse Close that still remains today under the name Old Playhouse Close. For some reason, Phillimore called it 'Theatre Close' when he depicted it in Edwardian times, but this must have been a mistake, since the close never had that name. He is right, however, in claiming that the Revd John Home's blank verse tragedy *Douglas* was performed here, with success, in 1756. In 1767, the opening of the New Theatre Royal led to the closing down of its notable predecessor in the Canongate. Tobias Smollett lived in Old Playhouse Close for a while and wrote *Humphrey Clinker* here. When seen by Phillimore, and even when the Royal Commission on the Ancient Monuments of Scotland came to call in 1951, Old Playhouse Close looked its old attractive self, but the house facing the Canongate was partially reconstructed in 1956–57, although the characteristic semicircular stair tower still remains intact today.

Above right: Smollett's House

St John's Street, accessed from the Canongate through a vaulted passage, is today a thoroughfare to Holyrood Road. It is said to have taken its name from the Knights of St John, who had a house in this district, but this is considered 'not proven' by the historians. The four-story house facing the Canongate, with its prominent five-story tower at the back, was constructed in 1755, and the remainder of the street was completed in the 1750s and the 1760s. It was a fashionable street, inhabited by many aristocrats – the philosopher Lord Monboddo and the Earls of Hyndford, Dalhousie and Aboyne among them. Much of St John's Street is a sorry sight today, but the large house facing the Canongate was sympathetically restored in 1955 and is today part of Moray House College. Here, in the summer of 1766, the celebrated author Tobias Smollett stayed with his sister Mrs Telfer; his former residence in St John's Street is honoured with a prominent plaque today.

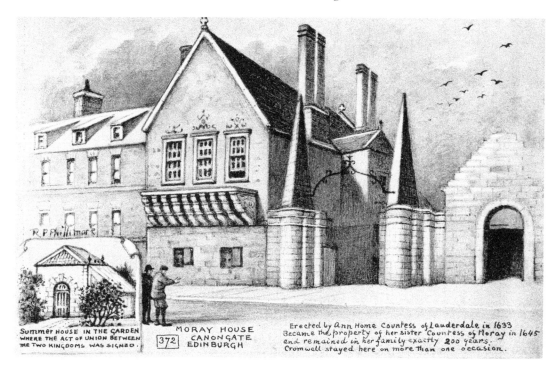

Summer HOUSE IN THE GARDEN WHERE THE ACT OF UNION BETWEEN THE TWO KINGDOMS WAS SIGNED.

372 MORAY HOUSE CANONGATE EDINBURGH

Erected by Ann Home Countess of Lauderdale in 1633 Became the property of her sister Countess of Moray in 1645 and remained in her family exactly 200 years. Cromwell stayed here on more than one occasion.

Above: Moray House

Ancient Moray House at what is today No. 174 Canongate, one of the best kept secrets of the Royal Mile, was constructed between 1618 and 1633 on the orders of Mary, Countess of Home, the daughter of Lord Dudley. In 1645, it passed to her eldest daughter Margaret, Countess of Moray, who made various improvements to the house, and gave it its name. Oliver Cromwell stayed at the house in 1648, and again in 1650, but for once without causing any damage. When the great Marquis of Montrose was taken to Edinburgh as a prisoner, a number of rival nobles stood on the balcony of Moray House to mock him as he was led along the Canongate. Moray House then hit evil times for a while: it became the office of the British Linen Company's Bank, and was then bought by the Free Church of Scotland from the North British Railway, for use as a teacher's training college. It today belongs to the University of Edinburgh and houses the School of Educations and Sport. It is only open to the public on Doors Open Day, for those of antiquarian bent to admire one of the few remaining aristocratic mansions of the Canongate, with the fine ornate plasterwork ceiling in what is controversially known as the 'Cromwell Room'.

Opposite left: Bible Land

Bible Land was built for the Incorporation of Cordiners in 1677, and the pedimented cartouche on the front of the house, featuring a Bible, a shoemaker's knife and a pair of cherub's heads, bears that date. The house became dilapidated in Victorian times, and was in immediate danger of being demolished in the early 1950s; the decision was made to save it, however, and it was sympathetically restored by the architect Robert Hurd in 1956. The old house is in good order today, and the ground floor houses two shops for souvenirs and Caledonian attire. Phillimore's card of Bible Land features the curious dwarf Geordie Cranstoun, who was featured in Kay's Edinburgh portraits and is said to have lived in the house.

495
SHOEMAKERS LAND (BIBLE LAND)
CANONGATE EDINBURGH.
At the end of eighteenth century it was
the abode of a curious dwarf known
as Geordie Cranstoun. He figures twice
in Kay's remarkable Scottish portraits

GEORDIE CRANSTOUN
after Kay

The old stocks of The Tolbooth
Now in The Antiquarian Museum
Edinburgh.

TOLBOOTH
CANONGATE
EDINBURGH
Built in 1591
on the site of
an earlier Tolbooth
251

Above right: Canongate Tolbooth

This is one of the most venerable buildings in the Canongate, erected in 1591 as a burgh centre for justice and administration, to replace an older Tolbooth that existed as early as 1477. The five-storey belfry tower was constructed first, and the building to the east added a few years later. The Burgh of Edinburgh had its own Tolbooth, which stood between 1403 and 1817, not far from the Mercat Cross. The Canongate Tolbooth underwent various alterations as the years went by but remained largely intact. The ground floor was used as a prison, and the courthouse and council meeting room were on the first floor. In 1654, a party of Scottish prisoners confined to the Tolbooth under a guard of Cromwell's soldiers escaped through by a rope from shreds of their blankets. In 1684 and 1685, when the prison was used for debtors and petty criminals, no less than fifteen prisoners escaped through various stratagems. The Tolbooth was largely used as a prison for debtors until the construction of Calton Prison in 1817, and the amalgamation of the burghs of Edinburgh and Canongate in 1856 rendered the building obsolete. The Tolbooth Tavern has been occupying part of the ground floor since 1820, and the remainder was a fire station for a while. In the 1870s, the Tolbooth was restored by the architect Robert Morham, who added various features of his own. In 1954, it became a general museum, with various Edinburgh exhibits, and in 1989, it became the People's Story, a museum about the life of ordinary working people in the past. One of the original prison cells can be seen on the ground floor, and the old council chamber on the first floor is the museum's main gallery.

390
THE MARQUIS of HUNTLY's
HOUSE · CANONGATE · EDINBURGH: R.P.Phillimore

The first Marquis of Huntly, George, is noted for having
murdered the bonnie earl of Moray in 1591.
The second Marquis, a precise puritane, and therefore
weill lyked in "Edinburgh", perished at the block at the
Cross of Edinburgh.
In 1753 the mansion was occupied by the Dowager Duchess
of Gordon. A series of tablets adorns the front of the building
containing the pious aphorisms usual in the 16th century.

Huntly House

This ancient Canongate mansion is recorded to have been three different dwellings in 1517, before being restored and united into one large mansion in 1570. Its purported association with George, 1st Marquess of Huntly, taken for granted by Phillimore when he came to visit in Edwardian times, remains entirely unproven. In 1647, the Incorporation of Hammermen bought the house and used it for meetings and for renting out flats. In 1671, the front block of the house was considerably enlarged. The Dowager Duchess of Gordon lived in one of these flats, rented from the Hammermen, in the mid-1700s; after she had moved away, her son Lord Adam Gordon took over the tenancy.

In Victorian times, the old house at what was now No. 146 Canongate became increasingly dilapidated: it had become workmen's lettings and was crowded with people. In 1924, when Huntly House was at risk of being demolished, it was purchased by the City of Edinburgh and restored under the direction of Sir Frank Mears, the principal assistant of Sir Patrick Geddes. When the restoration was concluded in 1932, the City Museum moved into the old house, and they have remained there ever since. In 1968, the Museum of Edinburgh was upgraded and extended, and it today presents fine collections of Edinburgh silver, pottery and porcelain to the curious visitor, as well as the collar and dinner dish of that extraordinary dog, Greyfriars Bobby.

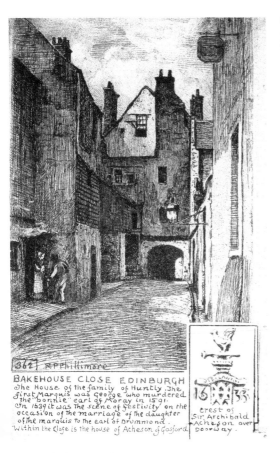

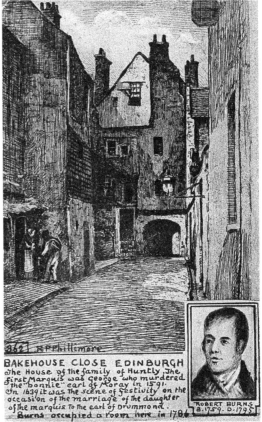

Bakehouse Close

Right next to Huntly House is Bakehouse Close, which was featured by Reginald Phillimore on two different cards, one of them commonly met with and showing the crest of Sir Archibald Acheson, after whom Acheson House is named, the other a scarce card featuring a portrait of Robert Burns, who lived in this close for a while. Bakehouse Close used to be named Hammermen's Close, from the Incorporation of Hammermen who owned Huntly House for a while, but it received its present name after the Incorporation of Bakers purchased part of Acheson House and installed a bakehouse there.

Bakehouse Close has benefited much from the restoration of Huntly House, and today it looks virtually unchanged from the time Phillimore came to visit; even the layout of the windows has not changed in the slightest, and there is still a doorway where the two people are standing in Phillimore's card. Indeed, Bakehouse Close is the conservationist's dream, providing a very good idea what this ancient part of Edinburgh looked like in the seventeenth and eighteenth centuries. The western boundary is Huntly House, which has a small hidden garden with carved stonework on display; the eastern boundary is No. 142 Canongate, which has been taken over by the Museum of Edinburgh, and Acheson House, which has its entrance through the museum front garden at No. 140 Canongate, and extends to the rear with an inside court that can be accessed from Bakehouse Close.

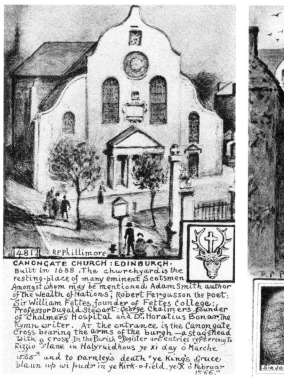

[481.] RPPhillimore

CANONGATE CHURCH : EDINBURGH.
Built in 1688. The churchyard is the resting-place of many eminent Scotsmen. Amongst whom may be mentioned Adam Smith, author of "the Wealth of Nations"; Robert Fergusson the poet; Sir William Fettes, founder of Fettes College; Professor Dugald Stewart; George Chalmers, founder of Chalmers Hospital and Dr. Horatius Bonar, the hymn-writer. At the entrance is the Canongate Cross, bearing the arms of the burgh — a stag's head with a cross. In the Parish Register are entries referring to Rizzio "slane in Halyruidhous ye xi day o Marche 1565" and to Darnley's death "ye King's Grace blawn up wi pudr in ye Kirk-o-Field, ye X o Februar 1566."

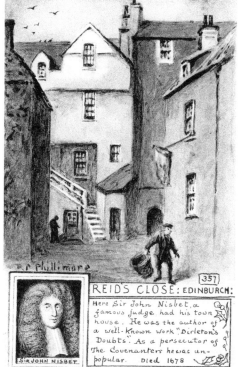

R.P. Phillimore

[357.]

REID'S CLOSE : EDINBURGH :
Here Sir John Nisbet, a famous judge, had his town house. He was the author of a well-known work "Dirleton's Doubts". As a persecutor of The Covenanters he was unpopular. Died 1678

SIR JOHN NISBET

Above left: Canongate Kirk

In the early seventeenth century, Holyrood Abbey served the inhabitants of Canongate as their parish church. James VII, who wanted the abbey to serve as the chapel of the Order of the Thistle, gave money to have a new church constructed in the Canongate itself. Founded in 1688 and finished in 1691, in a quaint Dutch style with a prominent gable, Canongate Kirk has served as the local parish church ever since. In its kirkyard, various notable people have been buried over the years, including the economist Adam Smith, the philosopher Dugald Stewart and the poet Robert Ferguson. A plaque on the east wall of the kirk, above a very worn gravestone, proclaims that according to tradition this is the grave of David Rizzio, transported here from Holyrood, but this seems unlikely since it would involve the reinterment of the remains of a Catholic with no living friends in a Protestant kirkyard at least 120 years after his death. Rizzio is probably buried in an unmarked grave near Holyrood Abbey, but no person knows for sure. Canongate Church is open to tourists during the summer months, and well worth seeing.

Above right: Reid's Close

Reid's Close, or rather Reid's Court, was named after the smith John Reid, who owned property here in the seventeenth century. Sir John Nisbet, a judge who harried the Covenanters, and who died in 1686, also lived here for a while. When Phillimore saw Reid's Close in Edwardian times, and even when the Royal Commission on the Ancient Monuments of Scotland came calling in 1951, a number of old and noteworthy buildings remained to be seen, but since then much has changed for the worse in these parts: at what is today No. 95 Canongate, an ugly 1960s block of flats faces the Canongate, and a hideous modern parliament building lurks behind it. Just like Brown's Court opposite, Reid's Close has been removed by developer's lorry, and nothing noteworthy or interesting remains there today.

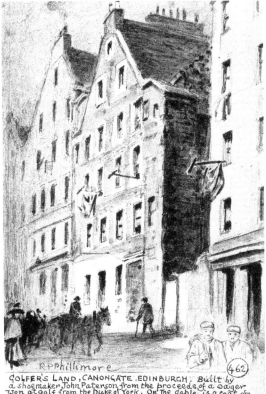

GOLFER'S LAND, CANONGATE. EDINBURGH. *Built by a shoemaker John Paterson, from the proceeds of a wager won at golf from the Duke of York. On the gable is a coat of arms with the appropriate crest of a hand holding a golf club, and the motto "Sure and Farre".*

Golfer's Land

There is a tradition that the old house at No. 81 Canongate owed its construction to the outcome of a match of golf. James Duke of Albany, later James VII, had challenged two English noblemen to a match, making sure that he had as partner the Edinburgh shoemaker and bailie John Paterson, who was known as a very skilful player. After the duke and the shoemaker had trounced their opponents, Paterson was richly rewarded, and he used the proceeds to construct a comfortable house for himself.

Golfer's Land, as the house became known, was a large irregularly shaped block, which presented its gable to the street. It had a panel with a Latin inscription, said to be from the pen of Dr Pitcairne, that can be translated as: 'When Paterson, in succession to nine ancestors who had been champions, himself won the championship in the Scots' own game, he erected this house, a victory more honourable than all the rest.' The verses are followed by the anagram 'I hate no person' for 'John Patersone'. Since the panel also featured a golf club, this panel provides support for the notion that the construction of the house was linked to a golfing victory, although those of a sceptical bent might object that the duke is nowhere mentioned, and that the panel rather seems to celebrate the win of a golfing tournament.

Golfer's Land was still standing, in good order, when seen and depicted by Phillimore in Edwardian times, and it remained intact, albeit internally much altered, when the Royal Commission on the Ancient Monuments of Scotland came calling in 1951. It is sad but true that this historic Canongate house was wantonly demolished as late as 1960, to be replaced with a hideous modern creation; the people behind this act of gross vandalism certainly have little to be proud of. The ground floor of the modern building is a restaurant called the Kilderkin, adorned with a reproduction plaque featuring a golf club and a coat of arms, and a metal plate telling the story, or perhaps rather legend, of old Golfer's Land.

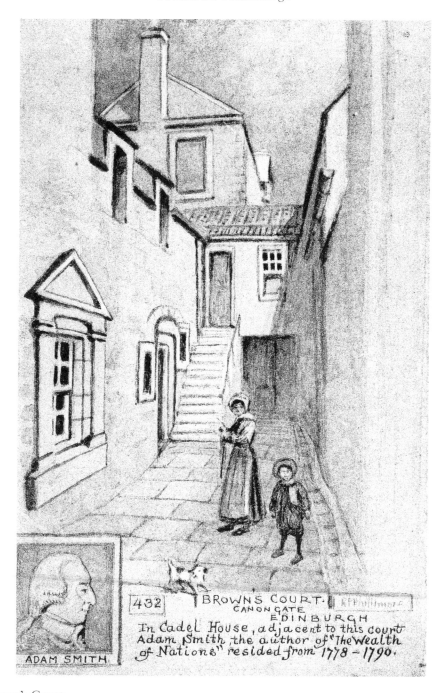

Brown's Court

This old court off the eastern part of the Canongate was named after Andrew Brown, of Greenbank and Blackford, who owned a house here before 1757. It had previously been known as Straiton's or Wilkie's Court, from two previous householders. Brown's Court was in good order and repair when depicted by Phillimore in Edwardian times, but then decay set in and the old close was demolished in 1948. A modern building today stands at the site, and Brown's Court is little more than an alleyway and a car park.

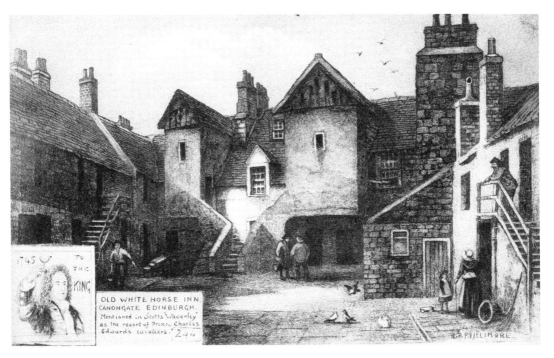

OLD WHITE HORSE INN
CANONGATE EDINBURGH.
Mentioned in *Scott's 'Waverley'*
as the resort of Prince Charles
Edward's cavaliers." 244

R.P.PHILLIMORE

White Horse Close

This famous old Edinburgh close was originally
called Ord's Close, from the merchant burgess
Lawrence Ord, who is likely to have been
involved in its construction in the late seventeenth
century. Its present name derives from a dubious
old tradition that the close was once a royal mews,
and that Mary Queen of Scots had her favourite
white palfrey stabled here. The White Horse Inn
at the bottom of the close was an important point
of departure for Newcastle and London in the old
days, with stabling in the undercroft entered from
Calton Road. In 1889, the buildings in White Horse
Close were purchased by Dr Barbour and his sister,
for use as working-class housing. Phillimore came
to call in Edwardian times to paint White Horse Inn
and Bishop John Paterson's House at the front of the
close. In 1951, when seen by the Royal Commission
on the Ancient Monuments of Scotland, White
Horse Close was called a unique survival from
the seventeenth century. However, between
1961 and 1964, the close was restored by Frank
Mears & Partners, with unhappy results: both
aesthetes and conservationists have lambasted the
'fake' appearance of these venerable old buildings
not far from Holyrood. Still, it must be admitted
that White Horse Close is a quaint sight today and
well worth visiting, although many tourists tend to
miss the narrow entrance from the Canongate.

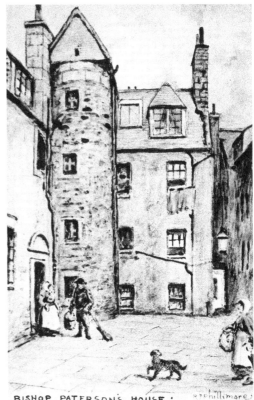

BISHOP PATERSON'S HOUSE :
WHITE HORSE CLOSE : EDINBURGH.

R.P.Phillimore

HOLYROOD PALACE AND ABBEY

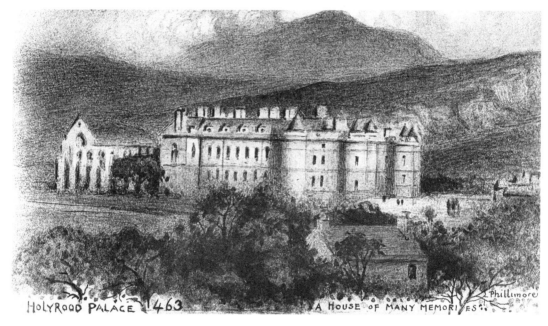

HOLYROOD PALACE 463 A HOUSE OF MANY MEMORIES. Phillimore

Above and opposite: Views of the Palace and Abbey

One of Phillimore's Holyrood cards, No. 463, shows the palace and abbey with Arthur's Seat in the background. Another card, No. 396, shows the old court house or gatehouse to Holyrood Palace, a former prison that today houses the office of the High Constables of Holyrood, whose responsibilities include guarding the Queen when she is in residence. Three of Phillimore's cards show Holyrood Abbey, said to have been founded by David I in 1128, under singular circumstances. After the king had been unhorsed and charged by a furious stag, the animal was frightened off through divine intervention, when a holy cross descended from the sky. Reconstructed at a grand scale between 1195 and 1230, it functioned as Edinburgh's second religious centre for centuries to come.

During the Rough Wooing, the marauding English armies plundered Holyrood Abbey in 1544 and 1547 – the roof was stripped of lead and the bells stolen. After repairs, the abbey was restored to its former glory, and it was the site of the coronation of Charles I in 1633. His successor James VII installed a Jesuit college at Holyrood Abbey. The Protestant congregation was moved to the newly built Canongate Kirk, and the abbey was converted to a Roman Catholic Chapel Royal and a chapel for the Order of the Thistle. After James had been dethroned in the Glorious Revolution of 1688, the Edinburgh mob plundered Holyrood Abbey, destroying the Chapel Royal and desecrating the royal tombs. A period of neglect and decay followed, and in 1768 the roof collapsed, leaving the abbey in its present ruinous state. Phillimore depicted the still impressive West Door, the Chapel Royal and the great window, with an appropriate poem that might well be of his own composition, although there is nothing to support that the abbey ruins are haunted.

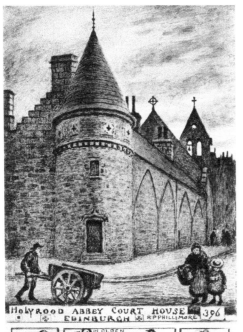

HOLYROOD ABBEY COURT HOUSE EDINBURGH · R·P·PHILLIMORE · 396

IN OLDEN TIMES
A REFUGE FOR DEBTORS
OUT RUNNING THE CONSTABLE

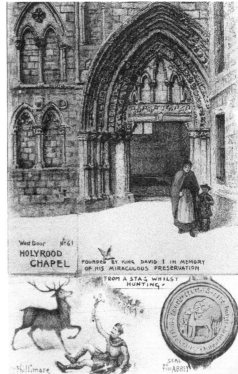

West Door Nº 61
HOLYROOD CHAPEL

FOUNDED BY KING DAVID I IN MEMORY OF HIS MIRACULOUS PRESERVATION

FROM A STAG WHILST HUNTING.

Phillimore

SEAL OF THE ABBEY

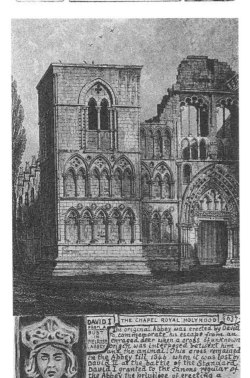

DAVID I THE CHAPEL ROYAL HOLYROOD 637
BUST IN MELROSE ABBEY

The original Abbey was erected by David to commemorate his escape from an enraged deer when a cross of unknown origin was interposed betwixt him and the animal. This cross remained in the Abbey till 1346 when it was lost by David II at the battle of the Standard. David I granted to the canons regular of the Abbey the privilege of erecting a borough betwixt their church, and the Netherbowgate afterwards known as the Canongate

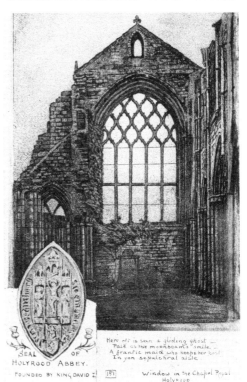

SEAL OF HOLYROOD ABBEY.
FOUNDED BY KING DAVID I. 151

Here oft is seen a gliding ghost —
Pale as the moonbeam's smile. —
A frantic maid who keeps her post
In yon sepulchral aisle.

Window in the Chapel Royal Holyrood

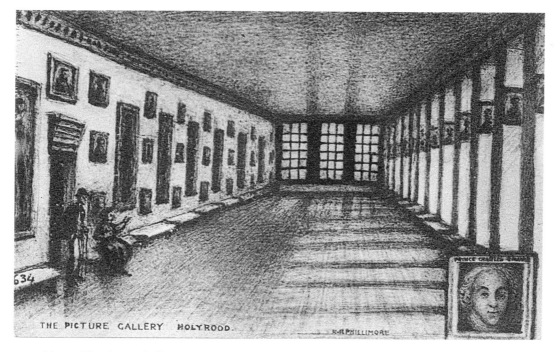

THE PICTURE GALLERY HOLYROOD. R·R·PHILLIMORE

Above: The Great Gallery

The entrance to Holyrood Palace goes to the Great Stair, the Royal Dining Room, the Throne Room and the Drawing Rooms, through the King's Apartments to the largest room in the palace, the Great Gallery. The view from the east windows show the buttresses of the ancient abbey. The Great Gallery was devised by Sir William Bruce along a simple classical scheme, and it houses an extensive collection of portraits of all the Kings of Scotland, both real and legendary, from Fergus I to James VII, within fitted frames. In 1745, Prince Charles Edward Stuart held a ball in this room during the Jacobite occupation of Edinburgh, and a few months later, the government troops were quartered here. When the exiled Comte d'Artois took refuge in Britain in 1796, he was offered apartments at Holyrood, and the Great Gallery was refitted as a Roman Catholic chapel for the royal suite. Today, the Great Gallery is occasionally used for various royal functions, like investitures, state banquets and receptions.

The Apartments of Mary Queen of Scots

Certainly the most interesting part of Holyrood Palace is the apartments of Mary Queen of Scots, situated on the second floor of James V's tower. Mary lived here from 1561 until 1567, with her husband Henry, Lord Darnley, occupying the floor below; a narrow spiral staircase connected the two. The apartments included a bedchamber, off which was a small supper room, and an outer chamber called an audience chamber by Phillimore. The outer chamber today contains a large collection of Stuart and Jacobite relics. In a niche is a modern stained-glass image of St Margaret to mark the site of Queen Mary's oratory, which was still there when Phillimore came to visit.

Queen Mary's supper room has kept a certain notoriety because of the murder of David Rizzio, committed in March 1566. Rizzio had joined Mary's household in 1561, and he was appointed her French secretary, a post of considerable influence. Scotland was home to a considerable population of angry, dissatisfied noblemen, and many of them joined forces to conspire against Rizzio, since they found it an abomination that this foreign upstart gained prominence at court. They decided that Rizzio must die, and cunningly swore the weak and foolish Darnley into the conspiracy, persuading him that the Italian was Mary's favourite in more ways than one, and that he had perhaps fathered her unborn child.

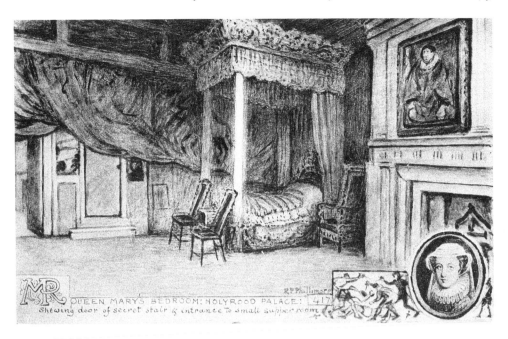

QUEEN MARY'S BEDROOM: HOLYROOD PALACE: 417
Shewing door of secret stair & intrance to small supper room

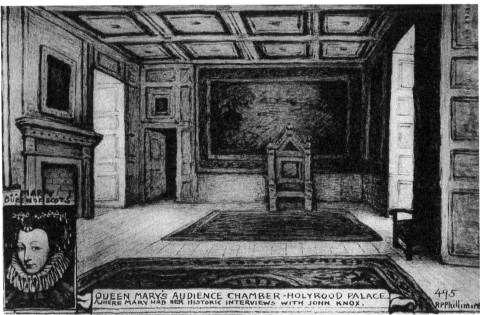

QUEEN MARY'S AUDIENCE CHAMBER · HOLYROOD PALACE.
WHERE MARY HAD HER HISTORIC INTERVIEWS WITH JOHN KNOX. 495

On March 9 1566, the conspirators forced their way into Holyrood, subdued the palace guards and made their way up the spiral staircase to Mary's apartments. The Queen was having a meal in her supper room, attended by Lord Robert Stewart and Lady Argyll, her equerry Arthur Erskine and the ubiquitous David Rizzio, when Darnley and the conspirators burst in upon them. Patrick, Lord Ruthven, was the first to speak out: 'Let it please your Majesty that yonder man David come forth of your privy-chamber where he hath been overlong!' Mary was able to hold the conspirators at bay for a while, the terrified Rizzio cowering behind her, but the murderous throng had little respect for her. All of a sudden, a number of noblemen

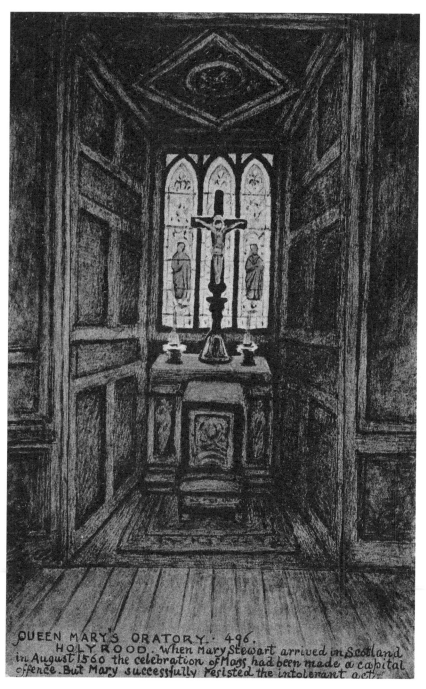

QUEEN MARY'S ORATORY. 496.
HOLYROOD. When Mary Stewart arrived in Scotland
in August 1560 the celebration of Mass had been made a capital
offence. But Mary successfully resisted the intolerant act.

rushed forward and grabbed Rizzio with a hearty goodwill, wrenching his fingers away from the queen's skirts. The wretched Italian could only scream out '*Giustizia! Giustizia! Sauvez-moi, Madame!*' as the conspirators dragged him through the bedroom into the outer chamber, where they finished him off with fifty-six stab wounds.

The apartments of Mary Queen of Scots were left unchanged for many years. The rooms were regularly visited by the curious, and in 1760 the future Duchess of Northumberland came to

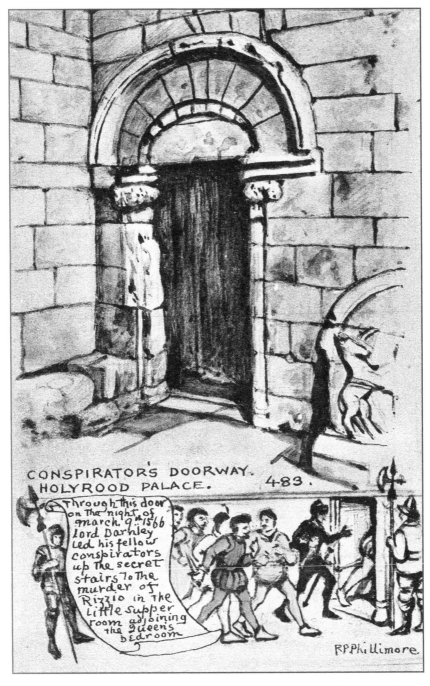

CONSPIRATOR'S DOORWAY.
HOLYROOD PALACE. 483.

Through this door on the night of march. 9th 1566 lord Darnley led his fellow conspirators up the secret stairs To The murder of Rizzio in The little supper room adjoining the Queen's bedroom

RPPhillimore

call: 'I went also to see Mary Queen of Scots' Bedchamber (a very small one it is) from whence David Rizzio was drag'd out and stab'd in the ante room where there is some of his Blood which they can't get wash'd out.' Throughout Victorian times a regular stream of tourists came to see these rooms, some of them exclaiming 'Cor blimey!' when they saw the bloodstain that could not be washed out. No bloodstain remains today, however, and it must be suspected that the Holyrood tourist guides had 'improved on' it with some fresh cow's blood.

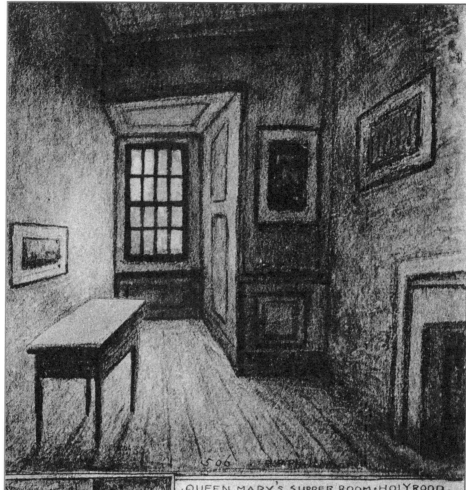

QUEEN MARY'S SUPPER ROOM · HOLYROOD.

It was in this room that the fatal supper party was held on the 9th March 1566. Into the recess of the window Rizzio retreated from the conspirators holding on to the Queen's dress, crying, "Giustizia! Giustizia! Sauve ma vie madame—sauve ma vie!" The first to strike a blow was George Douglas with the King's own daggar. Others dragged the poor bleeding creature through the bed-room to the door of the presence-chamber, where the conspirators, with fierce curses and yells completed their bloody work. Their victim was pierced by fifty six wounds.

PRIVATE STAIRCASE.
up which the conspirators ascended.

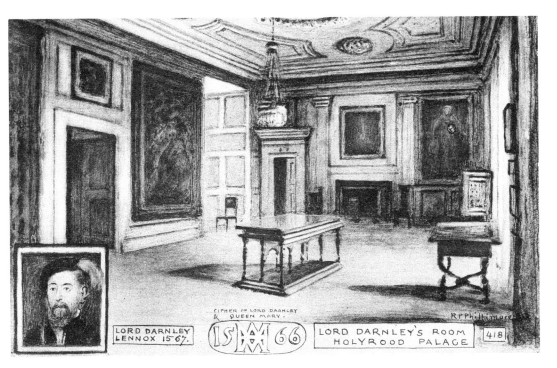

LORD DARNLEY LENNOX 1567.

CIPHER OF LORD DARNLEY & QUEEN MARY.

LORD DARNLEY'S ROOM HOLYROOD PALACE 418

R.P.Phillimore

Above and overleaf: Lord Darnley's Rooms

Henry, Lord Darnley, started his life with many advantages. A tall, handsome youth, he had received a good education. Mary Queen of Scots found him a promising swain and had no objection to marrying him in 1565. It was only with time that she found out his true character: weak, vain and dissipated. Phillimore's postcards show 'Lord Darnley's Room', which is today the Queen's Antechamber, and also 'Lord Darnley's Dressing Room', a small turret room off what is today the Queen's Bedroom at Holyrood.

The coward Darnley would not have long to exult after settling his score with Rizzio in such a definitive manner. Although Mary made use of her feminine wiles to keep her vacillating husband under control, her love for him was long gone and she conspired with the Earl of Bothwell and other loyalist nobles to get rid of him. Although her active participation in the events that were to follow remain a mystery today, she must have implied to the adventurer Bothwell that he could win her favour if something was done to end Darnley's career.

Mary invited Darnley to stay with her at Craigmillar Castle, but fearful that the loyalist nobles were planning some lethal 'accident' for him there, he preferred to stay at his house at Kirk o'Field near the Cowgate, where he believed himself to be secure. However, on 9 February 1567, some evildoers had loaded the vaults underneath the house with gunpowder; after a tremendous explosion, Darnley's dead body was found in the garden. Bothwell, who was widely suspected of being responsible for the murder, walked off scot-free, and later became Mary's third husband. However, by this time many people, the adherents of John Knox in particular, had had enough of Mary and her violent and immoral court. She would face imprisonment, and subsequent execution, among her enemies south of the border. As for the desperado Bothwell, he would end his days as a state prisoner in the hands of the King of Denmark, under miserable circumstances.

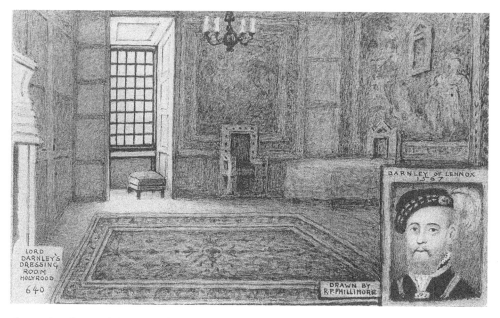

Opposite: Queen Mary's Bath

A much-overlooked feature of Holyrood Palace is the ancient and diminutive building known as Queen Mary's Bath. Situated in isolation next to busy Abbeyhill within sight from the main railway line from Edinburgh to the east, its position is an unpromising one, but still it deserves respect as Scotland's oldest existing garden building, constructed in the sixteenth century. According to a legend prevalent since early Victorian times, this wee pavilion had once been used for Mary Queen of Scots to bathe her snowy limbs in sparkling wine in order to preserve her beauty; although oft-regurgitated by credulous people even today, this tradition is without foundation, due to the very rustic and primitive design of the purported bath house. According to yet another legend, equally unsupported by fact, the dagger that killed Rizzio was found in the roof space during restoration work in 1789, having been deposited there by the conspirators.

In the 1830s and 1840s, Queen Mary's Bath was not treated with the respect due to such an ancient building and it fell into disrepair. Contemporary illustrations show the *soi-disant* bath house as the ornamental end of a terrace of very ordinary-looking tenement houses along Abbeyhill. A photograph in *Thomas Begbie's Edinburgh* shows that Queen Mary's Bath was at one time inhabited by a house painter, who had put his sign on the front wall. Purchased by the Crown and restored in the early 1850s, Queen Mary's Bath was admired by Queen Victoria in 1852 and 1860 and by the Prince and Princess of Wales in 1863. It was inspected by the Edinburgh architectural association in 1884. The tenements adjoining it were pulled down in Edwardian times, and the purported bath house once more stood in splendid isolation, having been cut off from the remainder of Holyrood Palace by the carriage drive.

Edinburgh scholars and antiquaries, both ancient and modern, have put forward a number of divergent theories about the original use of Queen Mary's Bath: had it been a garden pavilion, a small prison, a banqueting room, a summer house, or a ladies' retiring room for the adjacent tennis court? I would like to throw my hat into the ring with a novel and somewhat prosaic suggestion: a gardener's cottage. The *soi-disant* bath house is equipped with chimneys and fireplaces, indicating that it was intended for round-the-year human habitation, something that was fully feasible as late as the 1840s according to Begbie's photograph. This would tend to rule out many of the alternatives listed above. The version that it was a prison would appear unlikely, since the court house was not far away; the criminality at Holyrood was not such that two prisons were needed. A house of mystery, which is daily seen by thousands who do not appreciate its venerable historical antecedents, Queen Mary's Bath still stands today.

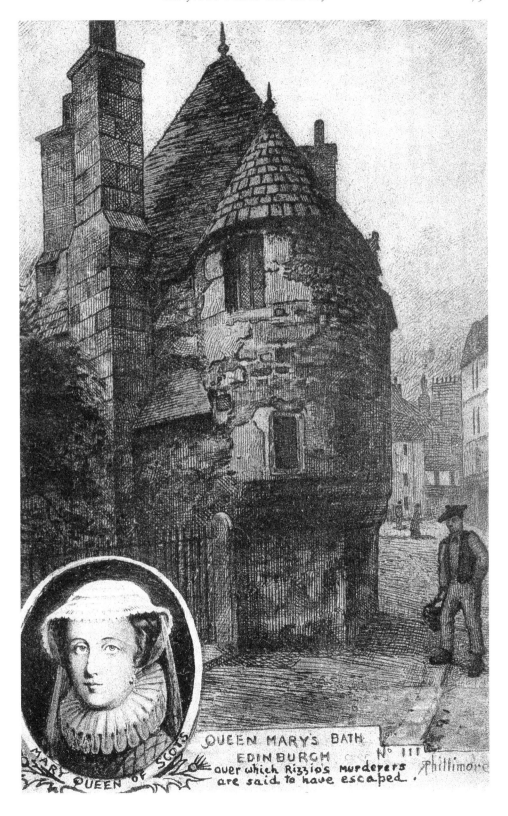

QUEEN MARY'S BATH
EDINBURGH No 111
over which Rizzio's murderers
are said to have escaped.

MARY QUEEN OF SCOTS

Phillimore

COWGATE AND THE
GRASSMARKET

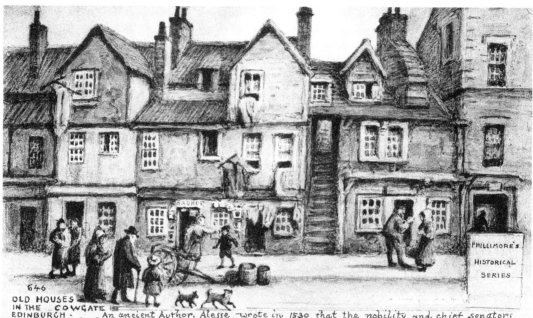

646
OLD HOUSES
IN THE COWGATE
EDINBURGH. An ancient Author, Alesse wrote in 1530 that the nobility and chief senators
of the city dwelt in the Cowgate and that none of the houses were mean or vulgar. It was
originally known as the Sougate or South Street. Building here must have begun
early in the 15 century.

Above and opposite left: Old Houses in the Cowgate, and Cardinal Beaton's House
The Cowgate was once a major thoroughfare with large and elegant houses, but it was a slum
already in Victorian times. Phillimore's postcard of 'Old Houses in the Cowgate' is most likely
based on a pre-existing print, also reproduced in Grant's *Old and New Edinburgh*. High School
Wynd got its name from the High School that occupied premises here as early as 1578. It was
long a quaint-looking street, with old and picturesque houses. Just opposite High School Wynd
was the house of Cardinal James Beaton, Archbishop of Glasgow from 1509 until 1522, which
was one of the finest houses in the Cowgate and stood for many years, before being pulled down
in 1867. Thus once more, Phillimore's card must be dependent on some pre-existing print. High
School Wynd is today devoid of interest, and not a single old or interesting building has been left
standing, a predicament it shares with much of the Cowgate itself.

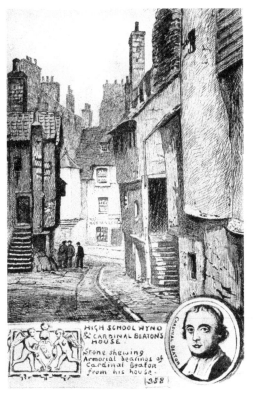

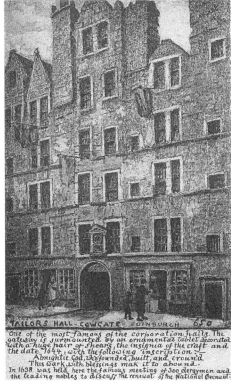

Above right: Tailor's Hall

The original Tailor's Hall of Edinburgh stood in Carrubber's Close, off the High Street, but in 1621, it was removed to new and larger premises constructed in the Cowgate, perhaps the most stately of all the corporation halls of Edinburgh. The front towards the Cowgate was a particularly grand affair, and behind it was a courtyard and then the main building with the hall itself on the first floor. In 1757, much money was spent on repairing and upgrading the old hall. It was sold in 1800, and some of the buildings were incorporated with a brewery. Tailor's Hall remained, although increasingly unloved and dilapidated, throughout Victorian times, to be seen by Phillimore in the 1920s to become the subject of one of his last Edinburgh postcards. In 1927, the Greater Edinburgh Club came to inspect the old hall, being quite impressed with this picturesque and imposing old building, in spite of its woefully dilapidated condition, and concluding that 'Had some little care been taken of the hall, it is not too much to say that we would have had in our city a group of buildings which by their association would have had no equal in Scotland.'

In the 1930s, there was an angry debate whether Tailor's Hall should be demolished: those of a motoring bent wanted the Cowgate to be widened, but the conservationists at long last showed some respect for this ancient building. It is sad but true that the Philistines won the day; in spite of the objections from the aesthetes, the Tailor's Hall's frontage to the Cowgate was demolished in April 1939. This part of the Cowgate has remained a sorry sight ever since. It was a car park for a while, but today, much of Tailor's Hall has been converted into a hotel, and another part is the Three Sisters Bar, with a prominent open beer garden at the front. A strange and little-known survivor, it almost seems to adapt to its brash and modern new façade, like an aging libertine visiting a party for frivolous young people, although some of the original the vaulted ceilings of the old hall is still there to admire today – for those sober enough.

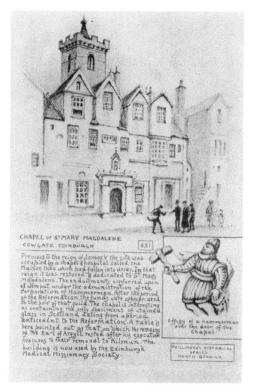

Above left: Chapel of St Mary Magdalene

This ancient chapel was constructed in the 1540s, being planned by the wealthy burgher Michael Macquhen, and finished by his wife Janet Rynd after his death. It was also to serve as the Guildhall for the Company of Hammermen. It still boasts some old and valuable stained glass. Some alterations were made in 1615–16, and a tower was added in 1621. The chapel was well looked after as the years went by, and it never appears to have been under the threat of demolition. Dwarfed by the towering George IV Bridge, and surrounded by humdrum Victorian buildings, it was used by the Medical Missionary Society at the time Phillimore came to call. In 1935, it was inspected by the Old Edinburgh Club, whose members were well impressed with one of the few pre-Reformation buildings still standing in Edinburgh. It remains open to visitors today, although few come to see this ancient Cowgate relic.

Above right: Ballantine's Close

This must surely be the most obscure close ever depicted by Reginald Phillimore: all reference books about Edinburgh ignore it, apart from the invaluable *Place Names of Edinburgh* by Stuart Harris. He claims that it can be seen on Ainslie's map of Edinburgh from 1780, but I cannot find it there, nor on any other early map, quite probably because it was considered too unimportant to be indicated. It is on the 1852 Ordnance Survey map, however, and the positioning of the curved steps on Phillimore's postcard coincides with that on this very detailed map. Ballantine's Close was situated between the second and the third houses to the east of the Vennel, roughly where No. 21 Grassmarket stands today. On the 1876 Ordnance Survey map, the dimensions and layout of the houses has changed, and Ballantine's Close is no more. No trace remains of it today, and Phillimore must have got hold of some old print of what it had looked like in olden times.

THE FLODDEN WALL
THE VENNEL EDINBURGH. 369

This fragment of the ancient wall runs from
Lavriston to the Grassmarket. It was
hastily erected by the citizens of Edinburgh
in 1513 after the disastrous battle of Flodden
in which the gallant King James lost his
life and many Scottish nobles perished.

A very interesting account of King James
and a thrilling description of the battle
of Flodden may be read in the Historical
novel, "The Wizard of Tantallon". Price 6

R.P.Phillimore

KING JAMES IV

The Flodden Wall

As we know, James IV invaded England in 1513, only to be defeated and killed at the disastrous Battle of Flodden. Fearful of an English invasion, Edinburgh decided to improve its defences. In 1514, a levy was imposed by the Town Council, and work on the Flodden Wall was begun. It was to extend to the Cowgate and Grassmarket parts of the city, and took much effort to construct, finally being completed in 1560. Between 1628 and 1636, the wall was greatly reinforced by the builder John Telfer. The Telfer Wall, as it was renamed, had six main gates: the West, Bristo, Potterrow, Cowgate, Netherbow and New Ports. This great wall became obsolete in mid-Georgian times, but due to the extreme sturdiness of its construction, it took a long time to demolish. The six ports are all lost and gone, but fragments of the wall remain all over central Edinburgh, particularly between the Grassmarket and Greyfriars. Along the Vennel, a steep lane from the Grassmarket to Heriot's Hospital, a long stretch of the Flodden Wall remains today, looking virtually unchanged since depicted by Phillimore in Edwardian times, in a felicitous postcard showing an old woman and a girl climbing up the Vennel, with two jolly schoolboys looking on; the Castle is in the background, high above the steep and forbidding Flodden Wall. At the bottom of the card, he makes a vain attempt to advertise his awful novel *The Wizard of Tantallon*, priced at only sixpence but nevertheless chronically short of readers.

GREYFRIARS AND
ITS SURROUNDINGS

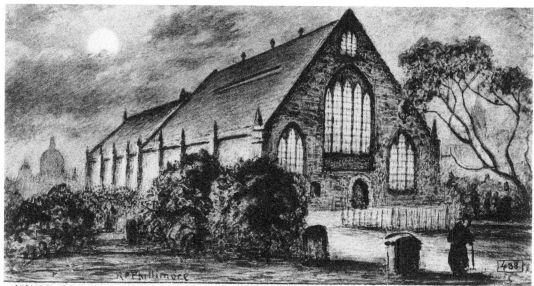

GREYFRIARS CHURCH. EDINBURGH. Here originally stood the Monastery and gardens of the Franciscan order of the Greyfriars, founded by James I in 1429. It was in the Greyfriars' church that the Solemn League and Covenant was signed in 1638: It has been described as the Westminster Abbey of Scotland.

Greyfriars Kirk

This was the first church constructed in Edinburgh after the Reformation. In 1562, Mary Queen of Scots allowed the Edinburgh town council to take over the grounds of a former Franciscan friary for use as a cemetery. Half a century later it was decided to construct a church on this site, since St Giles's was no longer able to accommodate the growing population. Although by no means small, Greyfriars was (and still is) quite plain and austere, and devoid of chapels, statuary and stained glass. It was first used for the funeral service of William Couper, Bishop of Galloway, in 1619.

In the coming years, Greyfriars was caught up in the religious fanaticism then current in Scotland. The National Covenant was read out from the pulpit in February 1638, to be signed by the nobility, gentry and burghers. Years of war and strife followed, and Greyfriars was used as a cavalry barracks by the profoundly Scotophobic Oliver Cromwell between 1650 and 1653. After the battle of Bothwell Bridge in 1679, 1,200 prisoners were taken to Edinburgh and 400 of them were held at Greyfriars on water and bread. Those who did not renege after five months in the 'Covenanters' Prison' were executed or transported.

In 1691, the infamous Lord Advocate Sir George Mackenzie, who had persecuted the Covenanters severely, was himself buried at Greyfriars. The ghost of 'Bluidie Mackenzie' is said to have haunted the kirkyard ever since, a phenomenon filling the pockets of the organisers of ghost tours while emptying those of neurotic and gullible tourists. Phillimore made three postcards of Greyfriars: the church itself, the south-western corner of the cemetery

476. SOUTH WEST CORNER OF GREYFRIARS CHURCHYARD. Here in 1679 were immured twelve hundred Covenanters who were taken prisoners at the battle of Bothwell Brig. Here they were penned up for five months in the open air suffering all the rigours of winter's cold, rain & snow. Hundreds of them died of hunger or were shot down and only a few survived. It is estimated that from 1661 to 1688 there were murdered & destroyed for the same cause about eighteen thousand persons.

THE MARTYR'S MONUMENT, GREYFRIARS CHURCHYARD, EDINBURGH. 371 R.P.Phillimore

In 1679 Twelve hundred covenanters were imprisoned in Greyfriars church-yard.

with the covenanters' prison, and the impressive Martyrs' Monument commemorating the cruel treatment of the Covenanters.

Greyfriars Bobby

It must be a somewhat disquieting thought for the dignitaries of Greyfriars that their kirk, whose history goes back four centuries, and with its churchyard well stocked with historic monuments, is today mainly known for having harboured a stray dog in mid-Victorian times. I am speaking, of course, of that extraordinary animal Greyfriars Bobby, whose meteoric fame has far eclipsed that of his ecclesiastical alma mater. For every visitor to old Greyfriars, there are ten who have come only to see and revere the three monuments to the most faithful dog in the world, who kept vigil on the grave of his master for fourteen long years.

Apart from the iconic dog monument in Candlemaker Row, duly depicted by Phillimore back in Edwardian times, there is Greyfriars Bobby's gravestone, erected in the triangular plot in front of the kirk, and that of his protean 'beloved master', thought by some to have been a Pentland shepherd and by others to have been an Edinburgh police constable. The pilgrims to Greyfriars come from faraway lands, attracted not by the Star of Bethlehem but by the light from the replica lamp post erected next to the dog monument; as gifts, they bring not gold, frankincense and myrrh, but dog biscuits, furry toys and ornamental wreaths, which they think Bobby's spirit would appreciate, once these votive offerings have been deposited next to his gravestone. Before leaving, like some devout Roman Catholic reverently touching a piece of the Holy Cross, or some pagan worshipper paying his respects to the shrine of a little yellow god not far from Kathmandu, they rub Bobby's shiny nose to secure themselves future prosperity.

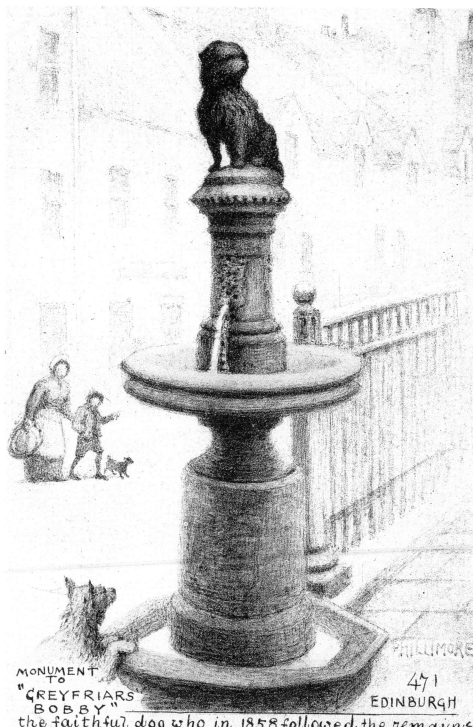

MONUMENT
TO
"GREYFRIARS
BOBBY"

471
EDINBURGH

the faithful dog who in 1858 followed the remains
of his master to Greyfriars' Churchyard, & lingered
near the spot until his death, in 1872. — Erected
by the Baroness Burdett Coutts in 1872.

There is no doubt that Greyfriars Bobby really existed: not less than fourteen eyewitnesses saw him at Greyfriars from 1860 until 1872. These observations do not support the myth of Bobby's 'faithful mourning', however. The jolly little dog went all over the district, ratting in the kirk and visiting friends as far away as Bristo to obtain a meal. It is also a fact that although the mawkish readers of the RSPCA's *Animal World* remained reverent to Bobby and his legend, many Edinburgh people 'in the know' were well aware that the story of the mourning little dog was a complete invention. When, in 1889, there was an application to erect a monument on Greyfriars Bobby's grave, Councillor James B. Gillies stood up in the Edinburgh Town Council to object that Bobby had just been a mongrel of the High Street breed, who had possessed enough sense to take shelter at Greyfriars; his story was just a penny-a-liner's romance, and Bobby never had any 'beloved master' at all. The objections of Gillies and others were heeded, and the children who had collected pennies for Bobby to get a gravestone rebutted. It would take until 1981 for this exception to be remedied, and a gravestone erected for the celebrated cemetery dog, in the presence of the Duke of York.

A set of cabinet card photographs of Greyfriars Bobby was produced soon after the little dog had found himself famous, in April 1867. They depict an elderly terrier mongrel, grey or dark yellow in colour, with cataracts in both eyes and afflicted with a benign congenital deformity known as facial asymmetry, causing the right side of the face to be wider than the left one. An early etching of Bobby by Robert Walker Macbeth, and two paintings of him by Gourlay Steell, clearly show the same animal as the cabinet cards. In contrast, the later portraits of Greyfriars Bobby are of quite another dog: a handsome black, brown and grizzled Skye Terrier. Since it would appear anomalous that two Greyfriars Bobbys would coexist in the cemetery at the same time, it must be suspected that after the old dog had expired later in 1867, he was replaced with another animal; the verger James Brown and the restaurateur John Traill, who both benefited from exploiting Greyfriars Bobby, are likely to have been involved in this scheme. As the journalist Thomas Wilson Reid expressed it, the old mongrel dog was soon 'honoured to death' and 'transformed into the similitude of a pure Skye terrier'.

Another objection to the story of Greyfriars Bobby is that it is part of a pan-European myth of extreme canine fidelity, a sentimental notion that after the master had died and been buried, the mourning dog would keep vigil on the grave. This notion was taken advantage by some canine vagabonds roaming into cemeteries, and remaining there because they were taken care of by kind and dog-loving people who thought the cemetery dog was keeping vigil on the grave of its departed master. There are forty-six of these cemetery dogs on record, the majority of them having been at large in Victorian times, from France, England, Sweden and the United States. In several instances, it was discovered that the cemetery dog had nothing whatsoever to do with the person it was presumed to be mourning.

Greyfriars Bobby is today surely Scotland's most famous dog, and one of the most celebrated canines in the world. His value to the Edinburgh tourist industry must be very considerable indeed. Perched on his iconic monument like some bizarre quadruped anchorite, the inscrutable Bobby receives the homage from the wide-eyed tourists and their flashing cameras and mobile telephones. However, unfortunate ones are unaware that the dog statue has feet not of solid bronze, but of brittle clay, and that they are worshipping not the original canine saint from 1867, but a false prophet usurping his fame.

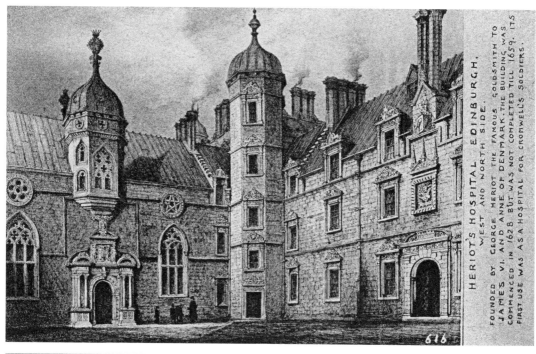

HERIOT'S HOSPITAL EDINBURGH, WEST AND NORTH SIDE. FOUNDED BY GEORGE HERIOT THE FAMOUS GOLDSMITH TO JAMES VI. AND ANNE OF DENMARK. THE BUILDING WAS COMMENCED IN 1628, BUT WAS NOT COMPLETED TILL 1659. ITS FIRST USE WAS AS A HOSPITAL FOR CROMWELL'S SOLDIERS.

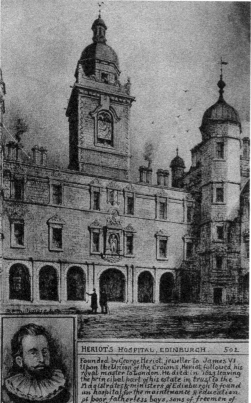

HERIOT'S HOSPITAL, EDINBURGH. 502.

Founded by George Heriot, jeweller to James VI. Upon the Union of the Crowns, Heriot followed his royal master to London. He died in 1623 leaving the principal part of his estate in trust to the Magistrates & ministers of Edinburgh to found an hospital for the maintenance & education of poor fatherless boys, sons of freemen of the city of Edinburgh.

GEORGE HERIOT.

George Heriot's Hospital

George Heriot was born in Edinburgh in 1563, the son of a wealthy goldsmith and Member of Parliament with the same name. He was apprenticed to his father's trade and admitted a member of the guild of Edinburgh goldsmiths in 1588. In 1597 he was appointed jeweller to Queen Anne by James VI, and in 1603 he followed the recently crowned James I of England to London, where he set up business in a large scale. He sold jewels to the rich and famous, lent money cannily and judiciously, and bought up property in the outskirts of London. He was nicknamed 'Jinglin' Geordie' for his great wealth, a reference to the gold guineas in his pockets. George Heriot had two legitimate children, but they had both perished at sea. He also had two young illegitimate daughters, for whom he made provisions in his will. Such was his wealth that even after various bequests to other relatives had been honoured after his death in 1624, no less than £23,625 remained for the construction of a grand hospital and school in Edinburgh, which was to bear his name.

George Heriot's great legacy was made good use of to construct a capacious building, a masterpiece of Scottish Renaissance architecture, in what was then the southern suburbs of

Edinburgh, which was to serve as a charitable school to look after the 'puir, fatherless bairns' of the capital for many years to come. Heriot's Hospital inspired two of Phillimore's postcards in Edwardian times, both of them rare and sought after today. The old hospital still stands as a very fashionable and successful school right in the middle of Edinburgh. If we are to believe the fact-based 1898 novel *Walter Crighton*, by Jamieson Baillie, that extraordinary dog, Greyfriars Bobby, began his career at Heriot's, before being pitched over the wicket gate to Greyfriars after making a nuisance of himself. Perhaps the present-day pupils of Heriot's should emulate their rowdy and mischief-loving Victorian predecessors and kidnap the Candlemaker Row dog monument back to its proper scholastic alma mater.

Clarinda's House

Agnes Craig was born in Glasgow in 1756, the third of four daughters of a prominent surgeon. She had many admirers due to her youthful good looks, of whom she preferred the lawyer James MacLehose. They married and had four children together, before she left him in 1780 due to his general caddishness. When he emigrated to Jamaica in 1782, she refused to accompany him there, preferring to move into a small flat in General's Entry, Edinburgh. She liked writing poetry, and when the celebrated Robert Burns came to Edinburgh in 1787, she was determined to make his acquaintance. They were mutually attracted to each other and exchanged letters in poetry and prose, Burns calling himself 'Sylvander' and Agnes 'Clarinda'. To a confidant, the amorous poet wrote that 'I am at this moment ready to hang myself for a young Edinr. Widow, who has wit and beauty more murderously fatal than the assassinating stiletto of the Sicilian banditti...' The chaste and pious Clarinda kept her ardent lover at arm's length, and the affair was never consummated. Burns had casual affairs with other women, including Clarinda's maidservant, and his marriage in August 1788 put an end to the affair for good. Clarinda never gave up hope of joining her husband in Jamaica, although he had fathered a child with his black mistress over there. She lived on until 1841, surviving Burns by forty-five years.

General's Entry was situated between Potterrow and Bristo Street and could be entered from both these thoroughfares. Clarinda's House was still there when Reginald Phillimore came calling in Edwardian times, and it also remained in 1938 when Edinburgh chronicler John Smith described the neighbourhood in the *Book of the Old Edinburgh Club*. Phillimore presumed that the 'General' providing its name had been John, Earl of Stair; Smith preferred Major-General Joseph Wightman, who had lived there from 1709 until 1724. The old buildings in General's Entry were demolished during developments in 1965. Today, a huge and newly erected university building stands on the spot, and all traces of General's Entry have been permanently eradicated.

CLARINDA'S HOUSE, GENERAL'S ENTRY, EDINBURGH. was situated at the junction of Bristo Street and Potter Row. There dwelt Mrs McLehose, the romantic 'Clarinda' of the notorious correspondence, in which the poet Burns figured as 'Sylvander'. The name of this court is supposed to have originated from the fact that a noted general, John, 2 Earl of Stair, resided here.

SOME EXCURSIONS TO
THE PROVINCES

DUCALD STEWART

CARLTON HILL EDINBURGH. 462 PHILLIMORE
ROYAL OBSERVATORY; DUGALD STEWART & NELSON MONUMENTS.

NELSON

Calton Hill

Calton Hill is, of course, far from the Provinces, but it is still a somewhat isolated part of central Edinburgh, a steep hill at the eastern end of Princes Street, home to a multitude of monuments. Phillimore's card features (from right to left) the Royal Observatory, the Dugald Stewart Monument, the National Monument and the Nelson Monument. Dugald Stewart (1753–1828) was a prominent philosopher of his day, and his monument was erected in 1831; it still stands in good order as a memorial to a quite forgotten scholar and worthy. The National Monument, dedicated to the Scottish soldiers and sailors who perished in the Napoleonic Wars, was proposed in 1822 and intended to be a facsimile of the Parthenon. Work began in 1826, but tools had to be downed in 1829 when the project had run out of money. Despite ambitious projects being brought forward to complete 'Edinburgh's Disgrace', as the half-finished monument was referred to, it still stands in an imperfect state today, and most people have become used to its somewhat odd appearance.

The most interesting monument on Calton Hill must be the Nelson Monument, dedicated to Lord Nelson after he had fallen at Trafalgar and completed in 1816, to resemble an upturned telescope in appearance. In its early years, it doubled as a naval signalling station. In 1852, a time ball was installed on top of the monument, designed to drop at exactly one o'clock, as a signal to ships at Leith or in the Firth of Forth to set their chronometers correctly. Since the time ball could not be seen in foggy weather, a time gun was set up at Edinburgh Castle in 1861. Both are still in operation today and integral parts of Edinburgh daily life. The Nelson Monument is open to visitors and houses a small display of nautical memorabilia; the main point of seeing it is the long climb, advisable only to the young and able-bodied, up to the top of the monument, where the views are magnificent indeed.

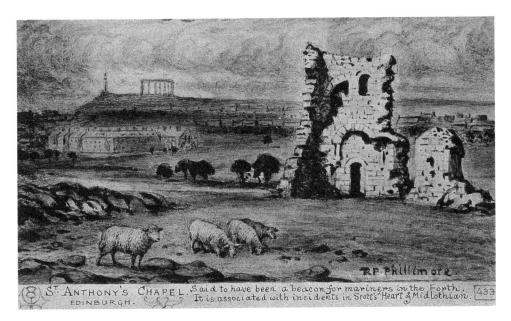

St ANTHONY'S CHAPEL. Said to have been a beacon for mariners in the Forth. It is associated with incidents in Scott's "Heart of Midlothian". 433
EDINBURGH.

St Anthony's Chapel

St Anthony's Chapel is the only building in the central area of Holyrood Park. It is a gaunt ruin today and has been in a dilapidated state for centuries. Already in 1426, the pope made a grant for repairs to be made to the chapel, suggesting that it was already quite old by that time. It last had a chaplain in 1581. It has been suggested that it belonged to Kelso Abbey, or alternatively that it served Holyrood Abbey as an outlying chapel for pilgrims, but without much solid evidence being brought forward. Once, St Anthony's Chapel had a vaulted roof, and a tower as well, but today only part of the north wall remains. The views from these ruins are almost as good as those from the Nelson Monument, with most of Edinburgh, and the Firth of Forth as well, visible in good weather.

DUDDINGSTON

Duddingston Loch

Duddingston was a village in the countryside, east of Holyrood Park, when seen by Phillimore in Edwardian times, but it is today situated right in the middle of the suburbs of Edinburgh. Duddingston Loch is the only natural loch in Edinburgh, and a nature reserve of some importance, with abundant seabird life including swans and ducks. The loch is well stocked with fish, and although the cormorants have decimated the roach population, there are perch, pikes and some carps of considerable size. Phillimore's card, which is hardly one of his most felicitous, depicts a view of Duddingston kirk across the loch, with some swans and a vignette showing a flight of mallards.

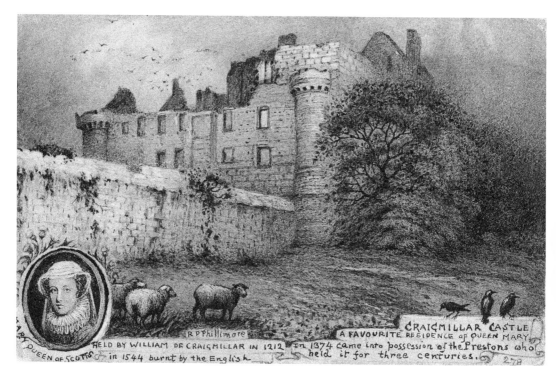

CRAIGMILLAR CASTLE
A FAVOURITE RESIDENCE OF QUEEN MARY.
R P Phillimore
HELD BY WILLIAM DE CRAIGMILLAR IN 1212. In 1374 came into possession of the Prestons who
MARY QUEEN OF SCOTS in 1544 burnt by the English. held it for three centuries. 278

Craigmillar Castle

Apart from Edinburgh Castle itself, present-day Edinburgh has castles aplenty. Merchiston Castle is today part of Napier University; Craigcrook Castle, where Charles Dickens, George Eliot and H. C. Andersen once attended the literary salons, is today a private residence; Colinton Castle, destroyed by the invading troops of Oliver Cromwell and then further demolished at the orders of the artist Alexander Nasmyth in 1804, with the intention to create a picturesque ruin, of which little survives today; this predicament is shared by Corstorphine Castle, of which only a doocot remains. There is reason to believe, from its ancient and distinguished history and the attractive position of its well-preserved ruins on a crag in the southern suburbs, that Craigmillar Castle can be considered the 'second' castle of Edinburgh. Dating back to the fourteenth century as a stronghold of the lairds of the Preston family, the castle came into prominence in 1566, when Mary Queen of Scots came to recuperate there following the murder of Rizzio and the birth of her only child at Edinburgh Castle. It was at Craigmillar that a group of nobles, the Earls of Argyll, Huntly and Bothwell prominent among them, hatched a conspiracy to murder the queen's husband Lord Darnley, something they succeeded in achieving in February the following year.

The Prestons sold Craigmillar Castle to the lawyer Sir John Gilmour in 1660, but the castle was unmodernised and outdated, and it became a ruin in the late eighteenth century. It was entrusted into state care in 1949 and is today open to visitors. Surrounded by parkland, it is a noble ruin indeed, with a mighty tower house containing a bedroom where Queen Mary is said to have slept and a grand banqueting hall. In the basement is an inhospitable dungeon, where an upright skeleton is said to have been found immured into a wall back in 1831. In its semi-rural surroundings, despite the sprawling Royal Infirmary nearby, Craigmillar Castle is well worth a visit, since it is spared the hordes of frantic tourists infesting Edinburgh Castle and offers those of a contemplative bent an opportunity to ponder castle life at the time of Mary Queen of Scots. Phillimore drew the castle from the north-west, showing the West Range with its corner tower and the main tower house behind.

Queen Mary's Tree, Little France

When he visited Craigmillar, Reginald Phillimore also made sure that he depicted another of the celebrated local sights, namely Queen Mary's Tree. This giant sycamore achieved prominence in mid-Victorian times, and is said to have been planted by Mary Queen of Scots during her stay at Craigmillar in the presence of Rizzio and other loyal retainers, later becoming quite a tourist attraction. Already in 1881 it showed signs of decay, and Mr Little Gilmour, the then owner of Craigmillar Castle, gave instructions to have the top cut off. In 1886, Queen Victoria was given a slip from Queen Mary's Tree and a picture of it at Dalkeith Palace. The queen gave instructions for iron railings to be put up to protect the old tree, and the loyal Scots obeyed her. After the royal associations of Queen Mary's Tree had become known, more than 100 people wrote to the gardener at Craigmillar asking for cuttings.

When Phillimore saw Queen Mary's Tree in Edwardian times, it was still an impressive tree. With his usual attention to detail, he depicted some ancient cottages nearby, known as Little France since they had once been inhabited by the French retinue of Mary Queen of Scots during her stay at Craigmillar Castle. A shepherd with six sheep and a sheepdog are just passing the tree, and an old woman watches them go by. When featured by the *Edinburgh Evening News* in 1924, the giant sycamore was rather diseased looking, however. The iron railings erected at the order of Queen Victoria were still there along with a plaque saying that the tree had been planted by Mary Queen of Scots around 1561. Tourists from all over the world still came to see it: there were saplings at Windsor and Balmoral; Lady Marjoribanks had donated a sapling to Ladykirk, which was planted with much ceremony in 1887; and Lord Rosebery had donated another to be planted at Linlithgow Palace. When featured by the *Fife Herald* in 1939, the old tree was in a bad way, and in 1953 it was in an advanced state of decay: only a stump around 10 feet high remained inside the iron railings. The plaque was later stolen, and Queen Mary's Tree was finally removed in 1975. Calls from traditionalist Scots to have another tree planted on the spot were not acted upon, and the site was soon covered with scrubs and brambles. The 'other' Queen Mary had planted a tree at the Little France caravan site in 1938, but this tree was sawed down when the caravan park was 'developed'.

The legend of Queen Mary's Tree being planted by the tragic queen's own hand is substantially flawed. Firstly, as we know, the only time she was at Craigmillar Castle was in late 1566, after Rizzio had been murdered at Holyrood; thus both the story that the tree was planted as early as 1561, and the account that Rizzio witnessed the planting, are likely to be false. Secondly and more importantly, it was a popular pastime in Victorian times to invent legends about particularly large and old trees. As a consequence, there are Queen Mary's Trees all over Scotland – at least ten of them at last count – including a famous hawthorn at Duddingston Manor that fell in a storm in 1840, a thorn in St Mary's College grounds in St Andrews, two yews at Castle Cary, and a chestnut at Cumbernauld Castle that was in the running to become Scotland's Tree of the Year in 2014. It would have taken a frenzied effort from Scotland's tragic queen to pull off such an arboricultural tour de force, whereas in real life she is not recorded as planting as much as a tulip.

Queen Mary's Tree: Little France: Craigmillar. Fenced in with iron railing by special wish of Queen Victoria.

COTTAGE OF JOHN TOOD - THE "ROARING SHEPHERD" SWANSTON. 416

The Roaring Shepherd's Cottage

In 1867, the father of Robert Louis Stevenson took the lease of Swanston Cottage, a large detached dwelling in a village just south of Edinburgh. Young Stevenson would spend some of the happiest years of his youth here. One of his friends was the rustic shepherd John Tod, known locally as the 'Roaring Shepherd' for his loud voice and colourful language. Tod lived in a small thatched cottage in Swanston village with his second wife Ann and had several children. He was the oldest shepherd in Swanston, and his sheepdogs were known for their prowess. Once, Tod lent his dog 'Snag' to another shepherd, and the clever canine soon had all the sheep in the pen. 'Man, that's an unco dog!' exclaimed the other shepherd. 'Ay!' roared John Tod, 'he could drive sheep up the bore of a gun!' John Tod and young Stevenson used to ramble in the hills together with the dogs 'Snag' and 'Cheviot', and the Roaring Shepherd told him various local stories and legends, which the great author later used in his books. Stevenson left a vivid description of Tod in *Longman's Magazine* of April 1887: 'That dread voice of his that shook the hills when he was angry, fell in ordinary talk very pleasantly upon the ear, with a kind of honied, friendly whine, not far off singing, that was eminently Scottish. He laughed not very often, and when he did, with a sudden, loud haw-haw, hearty but somehow joyless, like an echo from a rock. His face was permanently set and coloured; ruddy and stiff with weathering; more like a picture than a face; yet with a certain strain and a threat of latent anger in the expression, like that of a man trained too fine and harassed with perpetual vigilance. He spoke in the richest dialect of Scotch I ever heard; the words themselves were a pleasure and often a surprise to me, so that I often came back from one of our patrols with new acquisitions.'

John Tod expired in October 1881, from Bright's disease (chronic nephritis), complicated by erysipelas according to his death certificate. He was buried in Colinton Churchyard, later to be joined there by his wife Ann, who died in 1889. His sons William and David survived him, as did his daughter Janet, who later donated his muzzle-loader and two horns, as well as a photograph of her parents with their dog, to the Stevenson Memorial House at No. 8 Howard Place. David Tod died in 1930 aged seventy-three, and Janet Tod Fairbairn lived on until 1939. There are living descendants of the Roaring Shepherd both in Scotland and in the United States. As for John Tod's cottage, it was built in the early eighteenth century, along with the other cottages of Swanston village. It lacked electricity until 1949 and became increasingly dilapidated with time. In 1955, the cottages in Swanston Village were purchased by Edinburgh City Council, and competently restored in 1957–61 to be rented out as council houses, although the 'right to buy' clause has meant that nearly all of them are in private hands today. The Roaring Shepherd's old cottage remains in good repair, looking virtually unchanged since Phillimore's time.

CONCLUDING REMARKS

This paragraph will conclude Reginald Phillimore's postcard tour of Edwardian Edinburgh, a travel around the Royal Mile and other parts that I hope the reader has enjoyed. Phillimore was a firm traditionalist, with disdain for anything modern, a concept into which he included the New Town: only one of his cards was inspired by its Georgian splendour, namely that of Sir Walter Scott's house. Having received some degree of training as a historian during his Oxford years, he had a fascination with anything old and quaint; in particular, he liked to poke around in the closes of the Royal Mile, to investigate their history and find out what worthies had lived there in ages past.

Some of the subjects for Phillimore's Edinburgh cards have been literally 'done to death' by the postcard industry, ancient and modern, like Greyfriars Bobby and Scott's Monument. Other of his cards, like those of Bakehouse Close and White Horse Close, are artistic and interesting, although hardly unique in the iconography of the capital. Yet other cards, like Brown's Court and Bishop Paterson's House, provide curious and little-known views of old Edinburgh.

Apart from their obvious historical significance, Phillimore's Edinburgh postcards are also of superior artistic merit. I hope that this book will help to promote something of a Phillimore revival, raising the awareness of his work among mainstream aesthetes and Edinburgh historians outside the circle of postcard buffs, to which his fame has until now been largely restricted.

A NOTE ON SOURCES

There are two previous books about Reginald Phillimore, namely J. Astolat, *Phillimore* (London, 1985) and D. Lindgren, *The Postcard Art of Reginald P. Phillimore* (Zaltbommel, 1991), but neither is satisfactory to the modern reader: sketchy, badly written and factually unreliable. In contrast, the privately published catalogues of Phillimore's postcards compiled by D. E. Beets are models of painstaking research, and they have been invaluable for the present volume.

With regard to Edinburgh history and topography, four key works have been D. Wilson, *Memorials of Edinburgh* (two volumes, Edinburgh, 1891); J. Grant, *Old and New Edinburgh* (six volumes, London); *The City of Edinburgh* (Edinburgh, 1951), complied by the Royal Commission on the Ancient Monuments of Scotland; and S. Harris, *The Place Names of Edinburgh* (Edinburgh, 2002). The Edinburgh Room of the Central Library holds the fifteen volumes of notes on the history of Edinburgh by Charles B. Boog Watson, as well as valuable collections of press cuttings. Specialist books have been consulted whenever needed.